IMAGES
of America

SIERRA COUNTY

ON THE COVER: Young men from the Civilian Conversation Corps (CCC) camps in Sierra County are shown with Elephant Butte Lake in the distance. The CCC implemented erosion and flood control measures, installed cattle guards and water tanks, built thousands of miles of fences and telephone lines, eradicated noxious weeds and insects, and attempted to control and eliminate rodents. It helped in the construction of trails, roads, and highways. It worked in building bridges, improving grasslands and grazing ranges, and fire protection. Its presence also benefited the economy of Sierra County. (Courtesy of the Geronimo Springs Museum.)

IMAGES
of America

SIERRA COUNTY

Cindy Carpenter and Sherry Fletcher

ARCADIA
PUBLISHING

Published by Arcadia Publishing
Charleston, South Carolina

Library of Congress Control Number: 2017956145

For all general information, please contact Arcadia Publishing:
Telephone 843-853-2070
Fax 843-853-0044
E-mail sales@arcadiapublishing.com
For customer service and orders:
Toll-Free 1-888-313-2665

Visit us on the Internet at www.arcadiapublishing.com

Thank you, to my dear husband, Jay, I love you forever. Thank you, children; I love you Beau, Amanda, Jake, Racheal, Jess, and Cindy Lou. I am so proud of the Christian values you have instilled in my grandchildren. I love you, my grandchildren, more than life itself: Lee, Cordell, Evie, Colten, amazing Grace, Jae Lynn, and the sweet soul that will be leaving Heaven and arriving in April (can't wait to meet you, Alice). Thank you, to my sweet sisters, Sherry, Jamie, and Kim. I dedicate this book to my late mother, Imogene—we miss you and Daddy.

—Cindy Carpenter

My thanks and love to my husband, Baxter Brown, my brave and committed son, John, and my late mother, Maxine Lane Fletcher-Cecil. Your memories, Maxine, helped inspire this book.

—Sherry Fletcher

CONTENTS

ACKNOWLEDGMENTS

We would like to take this opportunity to thank some very special individuals and organizations that helped in making this book possible. First of all, a thank-you goes to Caroline Anderson for being with us every step of the way and encouraging us! Thank-yous are also extended to Marilyn Pope with the Geronimo Springs Museum, Ann Welborn, Cindy Abel Morris at the Center for Southwest Research and Special Collections at the University of New Mexico, John Wilks of Chloride, Russell Woolf, La Vern and Jimmy Walker, Mary Moyers, Charity Lang, Daniel Terrazas, Kathleen Terrazas, Josh Bond, Garland Bills and Larry Cosper with the Hillsboro Historical Society, Deann Knull (thank you for the cords, the hospitality, and the cheerful attitude at the Geronimo Springs Museum), Hank and KeliKay Hopkins, Bill Hopkins and Shairlee Hopkins, Merry Jo Fahl, Brenda Nelson, and the late Daisy Wilson.

Unless otherwise noted, all images appear courtesy of the Geronimo Springs Museum.

INTRODUCTION

On April 26, 1884, the New Mexico Legislature passed House Bill 22, introduced by the Honorable Nicholas Galles, a Doña Ana County commissioner who lived in Hillsboro. Portions of land from Doña Ana, Socorro, and Grant Counties were conjoined to create a new governmental entity of some 4,180 square miles known as Sierra County. Historians say the area was mostly inhabited by Apaches known as the Mimbres or Gila Apaches. They called themselves the "Red Paint People" and later would be known as the Warm Springs Apaches after their homeland, Ojo Caliente.

The *Rio Grande Republican* of December 18, 1885, notes that residents throughout the Black Range blamed the military men for trouble with the Indians, claiming if "they [the military] were as good as they once were the Apache Indians would not have killed over sixty white settlers this summer or one for every Indian that has left the reservation—reservation, hell, reserved for pink skinned officers." The settlers cried out for vengeance against the Apaches.

The nearby San Mateo and Black Range Mountains made the area of Cañada Alamosa a good place to live and hunt. Monticello Canyon, with its perpetual spring water and wildlife, was viewed by Apache chief Victorio as both his homeland and birthright. Because of floods and Indian raids, many residents abandoned San Ignacio de la Alamosa and moved up Alamosa Creek Valley between the years of 1862 and 1866, establishing Cañada Alamosa, later renamed Monticello. Las Placitas was located three miles south of Monticello. The Sedillo Ranch was established there in 1848. The village of Cuchillo Negro, later shortened to Cuchillo, became important as a stage stop heading into the Black Range. Rio Palomas was founded in 1865 by four families, those of brothers José and Dosacino Montoya, Antonio Garcia, and Ysidero Torres.

The promise of silver and gold brought settlers and miners to the area. In 1883, the villages or mining camps representing the mining districts of the Black Range, Cuchillo Negro, Apache, and Palomas were Grafton, Fairview (Winston), Chloride, and Hermosa, respectively. The discovery of gold and silver created the towns of Hillsboro, Kingston, Gold Dust, and Lake Valley. The Sherman Silver Purchase Act was enacted into law in 1890, thereby increasing the amount of silver the government was required to purchase every month. The act required the US Treasury to buy silver with notes that could be redeemed for either the silver or gold. The act was expected to boost the economy of the nation, but the plan backfired when people turned in their notes for gold, thus depleting the government's gold reserves. The Panic of 1893 dropped silver prices, and the mines and towns began playing out.

Tragedies occurred. As recounted in Fr. Francis Stanley's book, *The Lake Valley Story*, tragedy struck the two little sons of Thomas Ingles near Lake Valley in 1893. The boys, ages seven and eight, entered the home of George Gregg. Gregg was not home at the time. They found a can containing giant mining caps. Being kids, they played around with them until the caps exploded. Gregg came home that evening and discovered everything covered with blood. Two small bodies lay in the bed, the older boy barely alive to retell the story of what had happened. The younger lay with his arms above his head, both eyes blown out. One of his arms had been blown apart

at the wrist and the other was mangled. He lay dead. The elder lay on his stomach with a hole in his abdomen. He told Gregg he had tried to carry his younger brother home but could not. Probably not knowing what else to do, he had carried or dragged his brother to the bed and lay beside him for about five hours before death mercifully took him.

Sierra County had small villages that would prosper and decline with the economy. Las Palomas was founded about 1877. The acequia (irrigation ditch) used by the town was destroyed in 1887 and the town was abandoned. Seven miles northeast of Hillsboro was Andrews, established around 1898. In less than 10 years, the town of Andrews was gone. Bentura Trujillo was the largest sheep owner in 1880 in the Cuchillo precinct. His home and farm became the center of the community of Chiz.

The town of Cutter started as a station for the Santa Fe Railway and was the shipping point for Black Range ore. As mining declined, Cutter suffered. The town of Engle was the closest railroad stop for the building of Elephant Butte Dam. In the early 1900s, the Diamond A, located near Engel, was one of the larger ranches in Sierra County. The small towns of Paraje, Canta Recio, Cantadero, San Albino, San José, Zapata, and Alamosita were covered by the waters of the Elephant Butte Reservoir. Elephant Butte Dam and Caballo Dam both contributed to controlling the floodwaters of the Rio Grande and producing electricity for the valley.

The Elephant Butte Land & Cattle Company encouraged Spanish settlers to homestead the area known as El Bonito (Spanish for "pretty") and then sell the land back to the company. Individuals such as Urbano Arrey kept their homesteads and prospered.

In the area about where the Caballo Dam is now, the Silva brothers discovered gold in the Caballo Mountains. Within 24 hours, the area received 500 individuals hoping to strike it rich. The Silva brothers sold all their interests to the Shandon Gold Company, a practice the majority of the miners followed once their claims were established. The area, called Shandon, would have only 150 people in 1905 and would disappear after a few short years, the gold having played out.

In 1910, Faunt (Fount) Sullivan filed the first homestead in the heart of what is now Truth or Consequences and built a bathhouse at the bottom of the hill. Settlers realized the benefits of drawing health-seekers to the mineral springs. The January 18, 1907, *Rio Grande Republican* reports that the hot springs at Palomas Hot Springs (later called Hot Springs and then Truth or Consequences) were a product of nature that was not receiving the "care and attention a paternal government" should give curative waters for the pleasure seekers as well as the unfortunate in need of the curative properties. It goes on to say the springs were being made the "watering hole" for "porcine pigs" and "pork does not need the seasoning that the waters of Palomas Hot Springs may give." That year, a letter sent to the Board of County Commissioners of Sierra County from the Commercial Club of Palomas Springs called for a public health nurse to inspect the bathhouses.

At one time, Sierra County had 26 different school districts. In 1920, there were 18 separate school districts in the county. The New Mexico Board of Education consolidated these rural school districts into the Truth or Consequences Municipal Schools on May 2, 1956. This marked the end of the shifting and reorganization of the county's independent rural school districts.

Forgive any omissions, as it is impossible to tell the history of Sierra County in one book. Enjoy!

One

THE BEGINNING OF SIERRA COUNTY

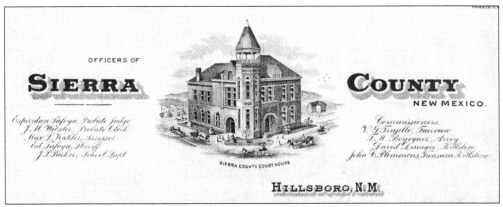

On April 26, 1884, House Bill 22—introduced by the Honorable Nicholas Galles, a Doña Ana County commissioner living in Hillsboro—passed. Portions of Doña Ana, Socorro, and Grant Counties were conjoined to create the 4,180-square-mile Sierra County. The name was taken from the range of mountains known as the Sierra de los Caballos. Sierra was the 18th county established in the New Mexico Territory.

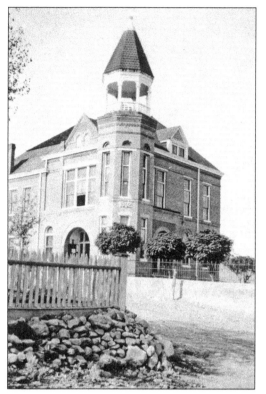

When Sierra County was formed, Hillsboro was named the county seat. Max Kahler, a land attorney and notary, argued that Hillsboro should not be the permanent seat of Sierra County because, in his opinion, nobody outside of Hillsboro wanted it. He claimed there were no large resources from mining or agriculture, Hillsboro had no other connection to the outside world other than a "long and weary stage route," and the town itself was located on school land, so no "perfect title" could be given to any of the city's real estate. Kahler felt Las Palomas, where he just happened to live and work, would make a much better choice. Hillsboro won out and became the seat for the new county. These photographs show the Sierra County Courthouse in Hillsboro. (Both, courtesy of Merry Jo Fahl.)

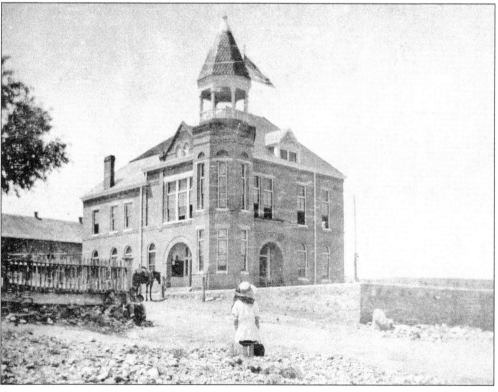

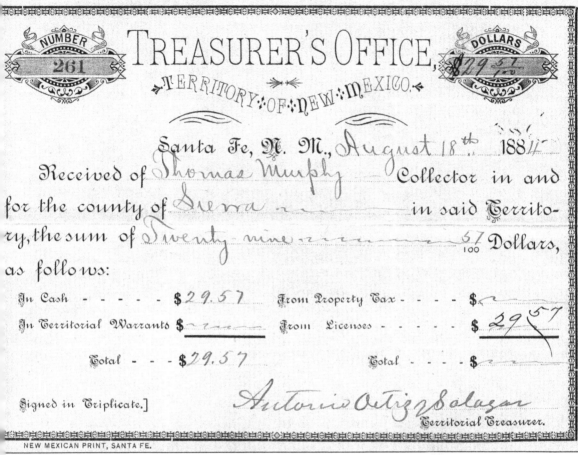

Thomas Murphy, whose name appears on this receipt, was appointed as the first sheriff of Sierra County in 1884. That same year, he would run on the Democratic ticket for sheriff against Nicholas Galles, a Republican, and win the nomination. Murphy also owned and operated a saloon in Lake Valley in 1883. It was said that if someone wanted a smile on his face, he should visit with Tom Murphy. In 1884, Murphy took seven members of a gang of rustlers from the Hillsboro Jail to Santa Fe for imprisonment. In early January 1885, Murphy tendered his resignation but then rescinded it when both the old and new county commissioners asked him to stay on. That same year, he succeeded in arresting and placing in jail the parties who had tried to kill the family of General Bowman. In Lake Valley, he apprehended and placed in the Hillsboro Jail James Wingfield, also known as Jake Maxey, who had killed Brown Hinch in 1883. (Courtesy of Sherry Fletcher.)

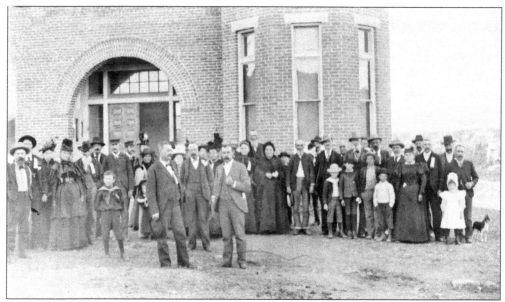

In 1892, the brick courthouse erected in Hillsboro was officially dedicated. The Kingston newspaper reported that the new courthouse looked "like a dance hall," but the competing newspaper noted, "The new courthouse resembles a great comfortable Chicago hotel since receiving its new furniture, carpets, mats, and blinds and in no way looks like a dance house." The county commissioners had given $500 to the county clerk to buy furnishings.

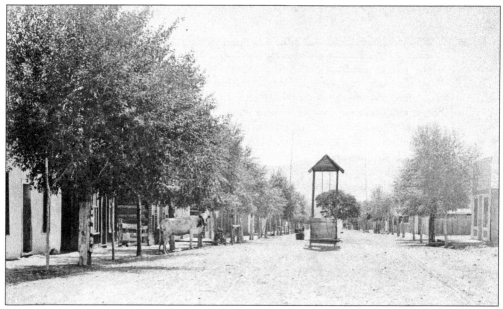

Newspapers touted that land in Sierra County was a good investment and could be bought at a low figure from its present owners, "the Mexicans." Reports noted that "anything will grow," and crops of wheat, corn, barley, oats, potatoes, grapes, vegetables, pears, peaches, and other fruit were available. The photograph shows downtown Chloride the year Sierra County was established.

Two

Indians Had Bad Immigration Laws

Not only did white men bring in diseases that would plague the Native Americans, but they also wanted Indian culture and civilization to change and adapt to the culture of the white man. Michael Steck designed an Apache farming program that was conducted between 1853 and 1860 on the Cuchillo Negro Creek and Animas Creek, both located in Sierra County. It was unsuccessful. (Courtesy of Sherry Fletcher.)

This original letter was obtained by Sherry Fletcher; page 1 is shown here. Walter Hearn writes to Eugene Manlove Rhodes detailing the events leading to the death of the "Apache Kid": "Dear Sir, I was talking with our old friend Johnie Dines yesterday and we were talking over old times. While talking we spok [spoke] of seeing a story of the Indian Kid. Johnie told me you wanted to get the true story of how the Apachie Kid was put to Death and by home [whom]. I am the one who organized a small group of six men and taken up his trale [trail] from when the Apachie Kid had shot at Cartie [Charlie] Anderson, John Hiler, and Johnie James and run them off his trale [trail]. I taken up his trale [trail] and we are the ones who got the Apachie Kid. I can give you the name of some of his Doings earlier than this. This was the second time to steal Horse from Charlie. Yours Resp. [Respectfully] Walter Hearn."

14

Pictured here is page 2, where Eugene Manlove Rhodes adds to the letter in his own handwriting: "Dear Vincent: Here is were [where] I have the edge for twenty years, various writers have been trying to get to [the] facts about killing of [the] Apache Kid. Not a whisper. . . . But to me as an old hand—they volunteer to tell it verily, if in any way I have deserved well, I am getting payment in full since I came back. EMR P.S. Walter Hearn and Johnny Dines are both in my stories, so are the rest of the boys." Rhodes, as a well-known writer of the American West, often used his experiences as a cowhand in the Tularosa Basin to document and expand on the life and times of the working cowhand.

Oral history claims that on September 10, 1906, the Apache Kid, a White Mountain Apache who formerly served as a scout for the US Cavalry, raided Charlie Anderson's ranch near Chloride, stealing horses and destroying property. A Mrs. Anderson and her daughter had gone to Chloride for the day, and the men were out riding the range. When the men returned to the ranch, a posse of four started out to try and find the Apache Kid. They got close enough to shoot at him but were unable to subdue him. A second posse of men, including Bert Slinkard, Bill Keene, Mike Sullivan (pictured), Water Hearn, Cebe Sorrel, and John and Harry James located the Apache Kid's camp and found evidence of belongings taken from various ranches and camps in the area. The cowboys killed one of three Indian men they saw approaching. They claimed it was the Apache Kid. However, it was said that Charlie Anderson claimed they never tried to claim the reward because they were never really sure if they had killed him.

Three

SILVER, GOLD, AND DRIED LAKE BEDS

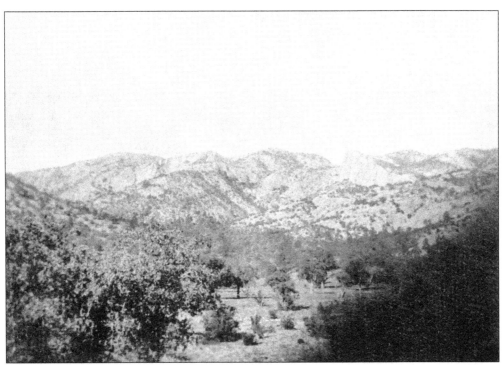

There were six mining districts in the Black Range Mountains (pictured): the Black Range, the Apache, the Palomas, the Limestone, the Cuchillo Negro, and the Iron Reef. Prospectors hoping to strike it rich and merchants hoping to strike it rich off of the prospectors came from all over as news spread about the rich finds in Hillsboro, Kingston, and Lake Valley. (Courtesy of Merry Jo Fahl.)

It is not known for sure how Hillsboro, originally spelled Hillsborough, got its name. One story says the prospectors put proposed names in a hat and Hillsborough was pulled out. Others say Joe Yankie, who first discovered the gold, named the town Hillsborough because it reminded him of his hometown in Ohio. The population was 250 by the end of 1878.

Oral history says prospectors Dan Dugan from Scotland and David Stitzel of Ohio found float (ore containing significant amounts of silver) on the east side of the Black Range Mountains in the spring of 1877. The next day, J.M. "Joe" Yankie, from Ohio, found gold. The mining town of Hillsborough (later shortened to Hillsboro) was born. Hillsborough started as a tent city, with the first house built in 1877.

Sent to Lake Valley by mining stock promoters back east, George Daly bought up not only George Lufkin's claim but also the claims of Lou McEvers and others in the Lake Valley area. This led to the formation of four mining companies in Lake Valley, all under the parent company of Sierra Grande Silver Mining Company. Oral history says in June 1881, Apache warrior Nana (in his 80s) and his men left Mexico and began raiding areas in the Sacramento, San Andreas, San Mateo, and the Black Range Mountains. In August, they were spotted on the Berrenda Creek (pictured). Daly and his militia of miners convinced a Lieutenant Smith and around 20 buffalo soldiers to join forces to track Nana down. On August 19 in Gavilan Canyon, 10 miles west of Lake Valley, Daly and the other men were ambushed, and Daly and Lieutenant Smith were killed. Despite being pursued later by reinforcements, Nana fled with captured horses, supplies, and ammunition. Oral history claims Daly's and Smith's bodies were later found mutilated. (Courtesy of Merry Jo Fahl.)

Hillsboro was 14 miles from Lake Valley, with the nearest railway at Nutt, about 25 to 30 miles away. At an elevation of approximately 5,253 feet, Hillsboro was located near a stream of water known as Las Perchas, in the foothills of the Black Range Mountains.

In August 1879, mines around Hillsboro were turning out ore at 160 ounces per ton, and prospectors were arriving daily in the area. Hillsboro was advertising for a much-needed physician. Good fortune had Dr. A.S. Warren setting up shop to work on all the aches, pains, and other conditions associated with a community of prospectors. (Courtesy of Merry Jo Fahl.)

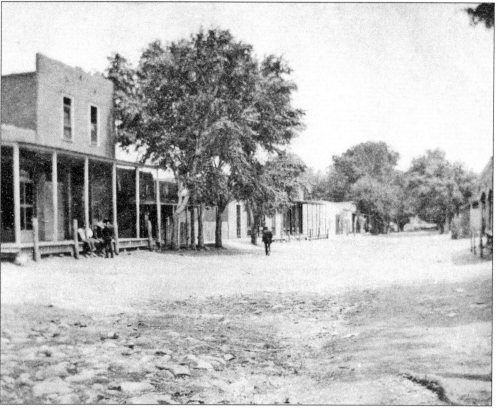

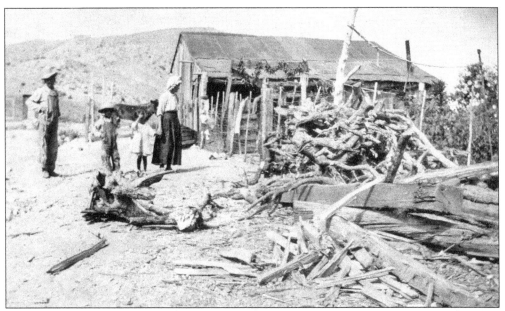

The *Thirty Four* reported on July 9, 1879, that there were 23 scholars at the Lake Valley School. It noted, "Little Mexican children greet you now with a 'good morning' spoken in very good English, which speaks well for the painstaking teacher, Miss Vaughn. The Indians are still lurking around but make tracks when the soldiers appear."

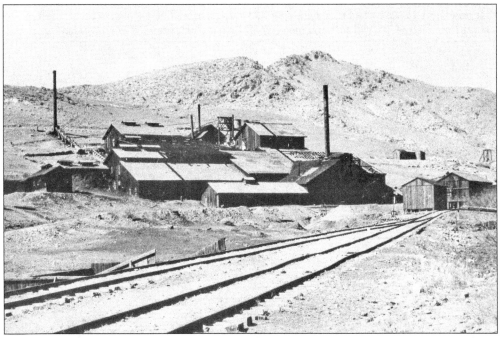

This photograph shows a mine, mill, and smelter at Lake Valley in the 1880s next to the railroad tracks. Four carloads of higher-grade and refractory ores were being shipped out from the Sierra Grande mines daily to Pueblo, Colorado. The monthly payroll was $80,000, and the owners had allegedly made $4 million. Between the Sierra Grande, Sierra Bella, and Sierra Apache, 300 men were employed.

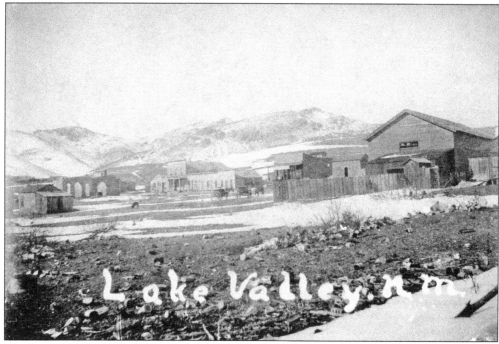

The September 9, 1882, *Rio Grande Republican* reports, "In Lake Valley, houses and stores are rapidly being removed from Sierra City to Lake Valley City, the new town site." The reporter notes that only three weeks earlier, that same spot had a single tent. The paper goes on to observe, "In a short time Sierra City will be but a memory of the past." (Courtesy of Merry Jo Fahl.)

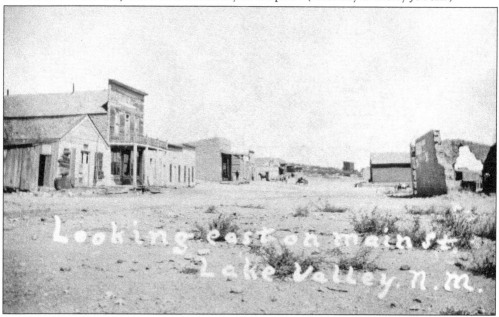

The first sheriff hired in Lake Valley was Jim McIntire. He had run a gambling saloon in Socorro prior to taking the job as sheriff. Lake Valley also had the Lake Valley Guard, Company 2 of the 1st Regiment of New Mexico Volunteers. The captain was John S. Young. This photograph shows early Lake Valley. (Courtesy of Merry Jo Fahl.)

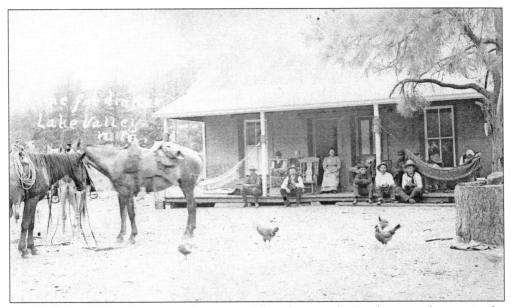

"Home for dinner" is written on this Lake Valley photograph. Cowboys are sleeping in the hammocks on the porch. C.C. Harris, a photographer from Kingston, had pitched a tent in Lake Valley in 1883 and was said to be "stamping with immortal youth the matchless beauty of our people," according to the *Las Cruces Rio Grande Republican*. (Courtesy of Merry Jo Fahl.)

In December 1883, Santa Claus visited the Lake Valley schoolhouse, bringing baskets of fruits, nuts, and candies. As he entered, the floor gave way, leaving Santa Claus in a big heap on the floor. Fortunately, no one was injured. Presents were distributed, and a certain Mrs. Calloway received a diamond ring said to be valued at $150. The photograph shows the schoolhouse built in Lake Valley in 1904.

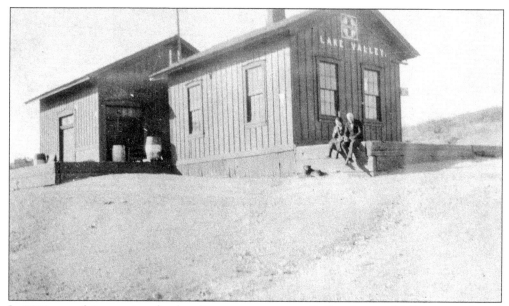

In 1884, complaints against land grabbers were rampant. Railroad agent McQuin complained that he expected somebody would try to fence in the railroad. Individuals were cautioned to be careful about messing with the railroad, because it could and would build the train depot one mile from town, and that would be very inconvenient for residents of Lake Valley.

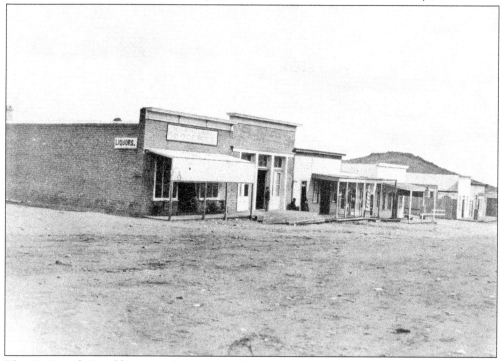

The *Rio Grande Republican* noted on January 12, 1884, that someone had complained about its "picturesque wild western style of writing up the shooting scrapes" at Lake Valley. The complainer noted that "no noses, fingers, toes or ears were swept up in Cotton's Saloon" after shootings. The picture shows the eastside of Lake Valley. (Courtesy of Merry Jo Fahl.)

In 1882, Maj. Albert Fountain asked Timothy Courtright (also known as "Longhaired Jim") to come to Lake Valley to assist the sheriff in ridding the area of its criminal element. Courtright was the first elected US marshal of Fort Worth and was said to be fast with a gun. It was said Courtright did clean the town up but only at the expense of the local cemetery. (Courtesy of Merry Jo Fahl.)

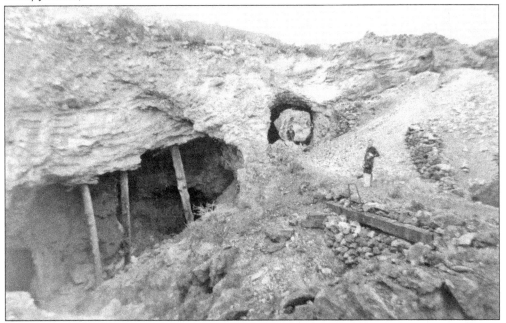

The Lake Valley mine known as the Bridal Chamber was one of the richest bodies of silver ever found. It yielded more than $3 million of pure horn silver between 1882 and 1886. Oral history says that the silver had the consistency of lead or putty in some places and could be cut into blocks by a handsaw. (Courtesy of Hillsboro Historical Society.)

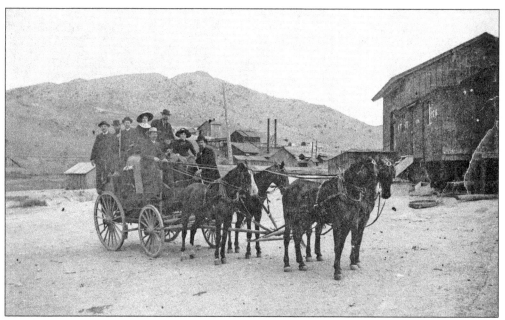

Oral history says that one man traveling to Lake Valley told fellow passengers he had made the momentous step of making his will and giving directions to which lunatic asylum he should be taken to when he returned from the trip. His reasoning was that all men were made crazy by a visit to the mines. The photograph was taken in front of the train depot. (Courtesy of Merry Jo Fahl.)

To keep up with the needs and wants of the people moving in to Lake Valley, businesses— including saloons, mercantile stores, hotels, restaurants, a lumberyard, a furniture store, and a boardinghouse— seemingly sprang up overnight. This photograph shows the boardinghouse on the right and the smelter on the left. (Courtesy of Merry Jo Fahl.)

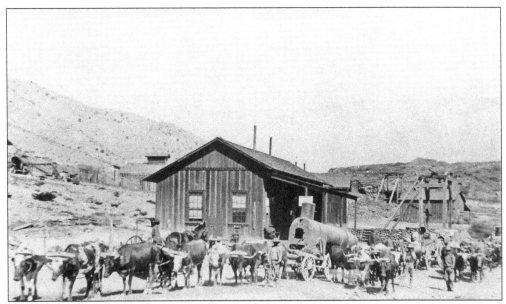

Lake Valley was thriving. John Saucier's bull teams are pictured hauling machinery from the Royal Arch Mine on Dry Creek to the Cook's Peak Mine. Tragedy was also present. In 1884, the four-year-old son of James Ballard found a bottle of carbolic acid (kept in homes to prevent smallpox). He took one swallow of the acid, and it was said that within a few minutes he was a corpse.

The fatal disease pleuropneumonia was raging among cattle in Sierra County in 1884, and the Grayson Cattle Company lost several hundred cattle in the Lake Valley area. The cowboy on the horse is identified as Stanley Dysard, born in Indiana in 1893. Dysard was participating in a cattle drive in the Lake Valley area. (Courtesy of Merry Jo Fahl.)

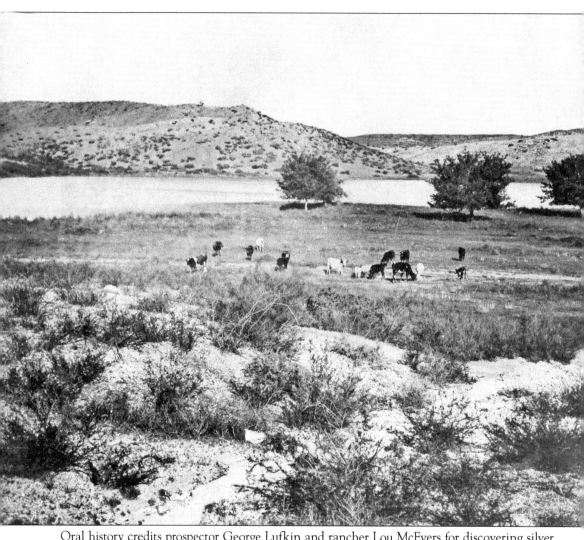

Oral history credits prospector George Lufkin and rancher Lou McEvers for discovering silver in Lake Valley. Early mining camps were known as the Daly Camp, Silver City, Silver Camp, and Lake Valley. Each site was vacated until only the town of Lake Valley was left. Daly Camp was also called Sierra City and the Silver Camp. In August 26, 1882, the *Rio Grande Republican*, under Lake Valley Topics, reported, "we had no idea that six months would have brought about so complete a transformation, both in the camp proper and in Sierra City." Further down, the writer notes, "We see on the left side of the road a group of men digging a well. This is the site of the new town that is to be." On July 16, 1879, the territorial newspaper *Thirty Four* reported the discovery of silver would bring a new town "at McEvers' Lake. It is the most romantic spot that we know of in New Mexico for a town site." That lake, pictured here, has since dried up. (Courtesy of Merry Jo Fahl.)

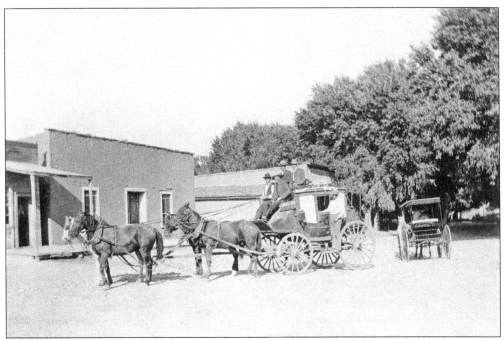

In 1885, the Armstrong brothers were proprietors of the Black Range Stage Company. The stage carried passengers daily except for Sunday. Operating from 1885 until 1914, it claimed to be the only stage line running into the mining country. In 1902, Robert Martin purchased the line from the Armstrong brothers. This photograph shows a stage arriving in Hillsboro.

In 1885, new potatoes were selling for 8¢ a pound, green chilies were 10¢ a pound, and Hillsboro property was selling like hot cakes. Hop Won Lung Lee vowed he could do more washing than any other Chinese in Hillsboro. Mr. L. Fuller, a former postmaster of Hillsboro, stole $800,000 from the Percha Bank at Kingston, landing him three years in the penitentiary in Pennsylvania.

Sadie Creech came to Kingston in the 1880s to start a brothel on a street named Virtue Avenue. Oral history says she told the miners that she was from England and had learned her trade in the Limehouse District of London. Despite her occupation, she was said to have donated her diamond pendant and then passed the hat around to the miners, gamblers, and other residents in Kingston to get the $1,500 needed to build the first church. When an epidemic of smallpox spread through Kingston, it was said that Sadie and "her girls" were there to care for the sick. Individuals claimed she would generously stake a miner or even support a family that had fallen on hard times. Sadie moved to Hillsboro in 1886, opening a second brothel. She also owned a hotel named Ocean Grove. When influenza hit, oral history says that Sadie cut her own dresses up to line the caskets for small children and used her carriage to carry those caskets to their final resting places.

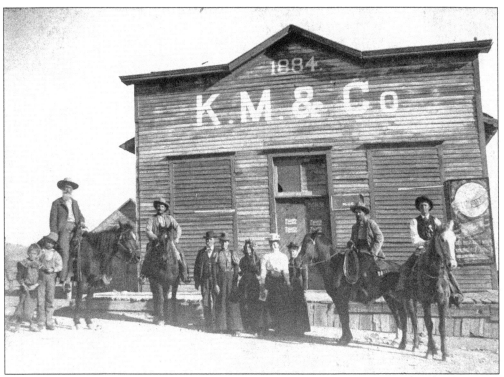

D.S. Miller, S.F. Keller, and Henry Herrin partnered in the general mercantile business in Lake Valley under the name of Herrin, Keller, Miller & Company. Later, Isaac Knight bought Herrin out, and the business became Keller, Miller & Company. The company also had stores in Hillsboro and Kingston, selling general merchandise and mining supplies. The individuals seen in the photograph are unidentified.

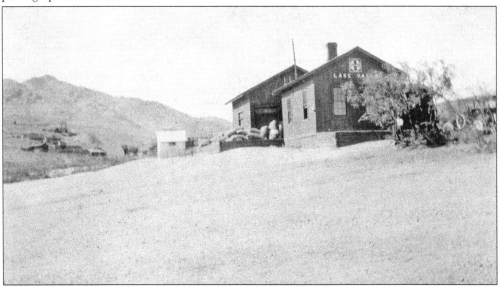

The Santa Fe Railway built a 13-mile branch from Nutt to Lake Valley around 1882. After the Panic of 1893, silver production in Lake Valley stopped, but the railroad continued service until January 6, 1931. The Lake Valley train depot is pictured. (Courtesy of Merry Jo Fahl.)

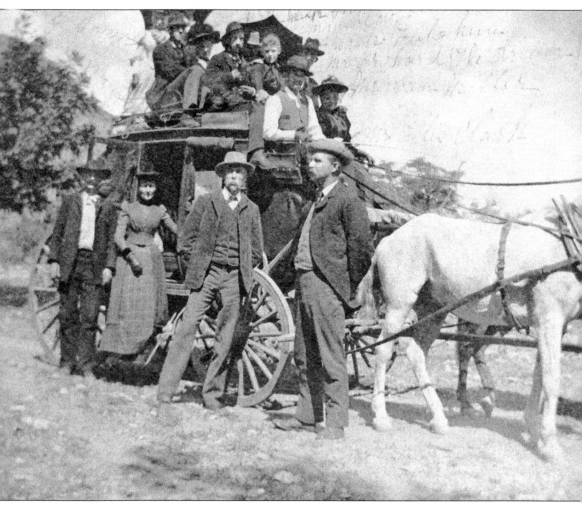

The driver of the stage is James "Henry" Orchard. Orchard married Sadie Creech on July 17, 1895. Together, they ran the Orchard Stage Line from Kingston to Lake Valley and the Orchard Hotel. Court records indicated a tumultuous marriage. In one incident, Sadie fired a revolver at Henry (she claimed it was an accidental discharge). Henry had her arrested for assault with a deadly weapon with intent to kill. The marriage failed. Sadie Orchard tried to the end to pass herself off as being from England. However, family facts, her will, and her funeral record state differently. Sadie was actually born in the United States. She was listed as a "hotel keeper" at her death in Hillsboro on April 3, 1943. On January 13, 1968, *Death Valley Days* ran an episode about "The Saga of Sadie Orchard," with Patricia Huston as Sadie Orchard. Several books have been written about her, and she is still celebrated in Hillsboro.

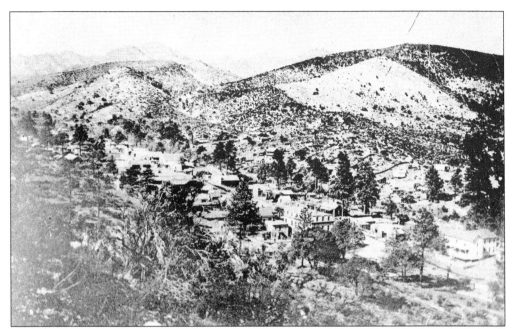

The *Albuquerque Journal* reported on October 25, 1882, that if Apaches who had "formerly prowled over that portion of the Territory [Kingston], stealing, scalping, and killing at their own sweet will, should venture into the Percha now, they would meet with a reception such as they wouldn't fancy, and very few of them would ever go back to tell the tribe what they had found." (Courtesy of Merry Jo Fahl.)

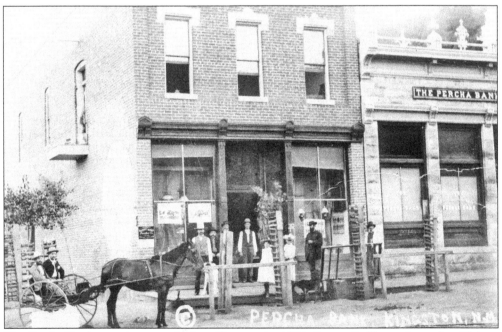

The Percha Bank, seen here, was built in Kingston in 1884. George R. Shane, formerly of Salem, Ohio, was promoted to cashier at the bank in 1891. According to one source, the building to the left was said to later house the Kingston Masonic Lodge. (Courtesy of Merry Jo Fahl.)

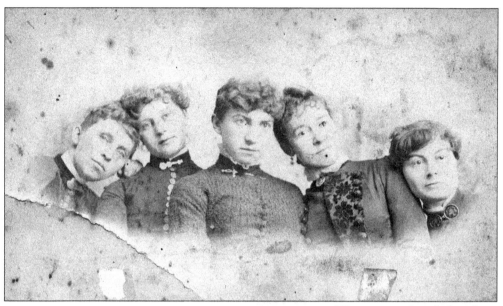

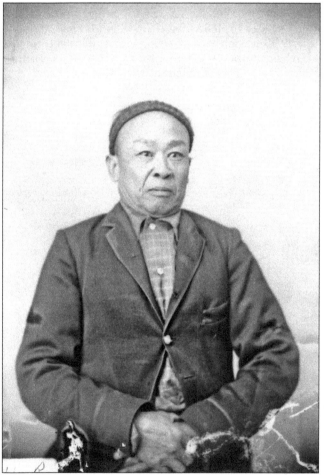

The women identified in the photograph are, from left to right, Nellie Russel, Edith Holmes, Pauline Mayer, Annie Moore, and Alice Anderson (Mrs. W.D. Nourse). There is no background on the reason for the photograph, but it is labeled "Belles of the Black Range." This particular range of mountains, about 70 miles long and up to 18 miles wide, lies almost entirely within the Gila National Forest.

The individual is identified as Chin Charley Hop Lee, a laundryman in Chloride in the early 1900s. The early newspapers indicated that there was a Hop Won Lung Lee who vowed he could do more washing than any other Chinese in Hillsboro. Although it is not known if they are the same man, Chin Charley did live in Hillsboro at one time. (Courtesy of Center for Southwest Research and Special Collections at the University of New Mexico [CSWR, UNM], 000-179-0329.)

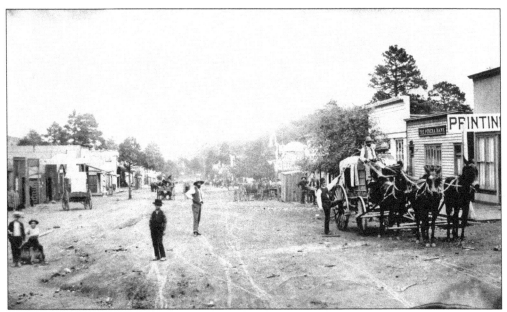

The October 12, 1886, edition of *the Las Vegas Optic* reports that "the Kingston paper reports that wine, women, song, hop joints, tinhorn gamblers and rounders abound in that mountain metropolis [of Kingston]." It was said that lots in town that could be purchased originally for $50 were now selling for $500. (Courtesy of Merry Jo Fahl.)

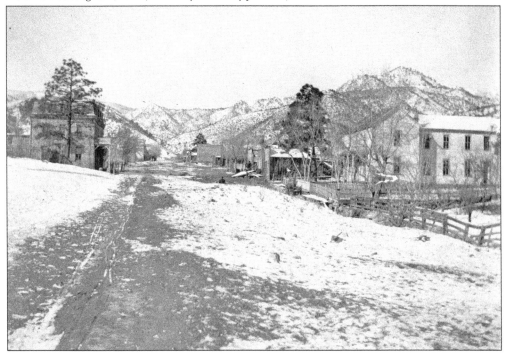

In December 1882, the papers reported that the town of Kingston had just had its second ball. The music was provided by a Kingston string band. Plans were to have these pleasant parties every two weeks during the winter months. Not to be outdone, Pretty Sam's Casino opened up in Kingston on Christmas Eve with a big party. (Courtesy of Merry Jo Fahl.)

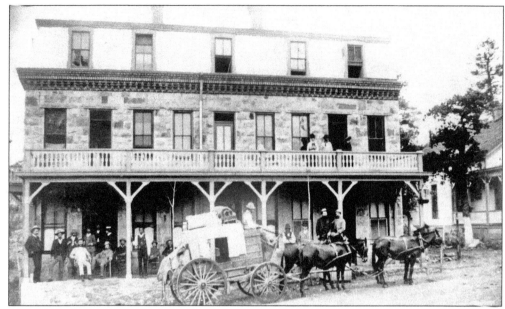

The three-story Victoria Hotel was built by Oliver Wilson and a man named Bryon between 1884 and 1885 in Kingston. In 1889, the newspapers touted it as the only first-class hotel in Kingston, safe from fire, furnished with Star Fire Extinguishers, and thoroughly overhauled and refurbished. It would appear there had been a fire. (Courtesy of Merry Jo Fahl.)

This photograph shows the Whithan toll gate house between Kingston and Hillsboro. The gate and posted notice of toll rates are to the left of a Mr. Steele, a local miner. The toll road, about a mile or so in length, passed through a Mr. Whithan's ranch property in the 1890s and the early 1900s. Whithan was a mining engineer and mineral surveyor. (Courtesy of Merry Jo Fahl.)

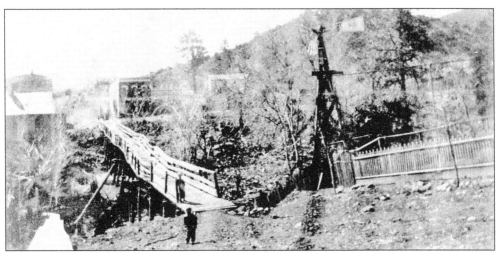

This photograph of the footbridge across Middle Percha Creek in Kingston was taken in the summer of 1904. At the end of the bridge and on the south side of Main Street is the two-story brick Fred Lindan Building. This building was the home of the Kingston Masonic Lodge for many years. (Courtesy of Merry Jo Fahl.)

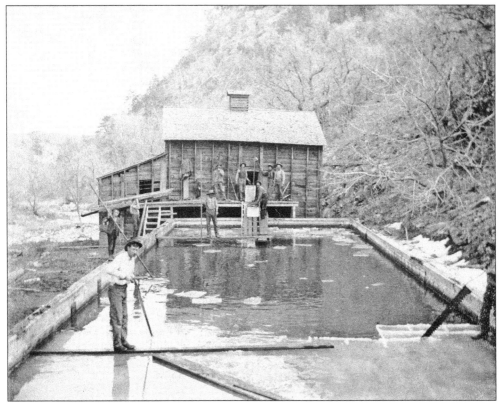

The men are harvesting ice at the icehouse in Kingston. Notice the pulley system being used to pull the heavy ice blocks from the water. The harvested ice was kept in the icehouse, where it was packed with straw or sawdust to insulate it from the heat. Some icehouses utilized their facilities to temporarily keep dead bodies cool. (Courtesy of Merry Jo Fahl.)

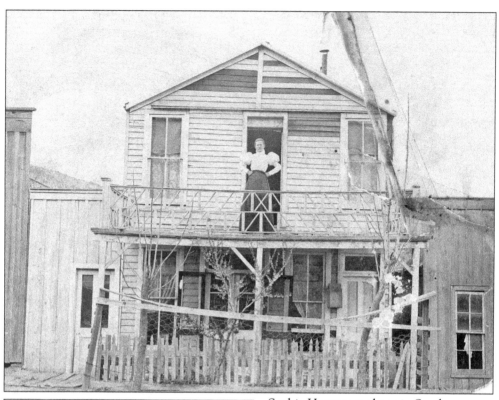

The Occidental Hotel

MISS SOPHIA HANSON, Proprietress.

Rates Reasonable.

Kingston, N. M. Nov. 13 - 08.

To the Hon Probate Court.
I file with the Court the following
plots or parcels of land in
the Kingston Town site. Kingston
Sierra Co. Territory of New Mexico,
as shown on map of the plat of the
Town site. as surveyed by Mr Parker.
1 plat or parcel of land situated
on the corner of Pine St. and Oak
Iron St. No's 9 and 10. Block 9.
100 feet. 2 lots. claim this plot,
by deed from former owners.
Also claim the plot or parcel
of land, in Block O, marked on
the plat - P. Jones. Also in Block
O. the parcel of land marked
on the plat - Fanning. Also in
Block O the parcel of land
marked on the plat - Sparks.

Sophia Hansen was born in Sweden around 1848 and emigrated to the United States in 1881. According to the details on this image, she owned the boardinghouse. In the 1910 census, she called herself a housekeeper in a boardinghouse. Portions of the letter at left indicate that Sophia also owned the Occidental Hotel at one time. In the letter, she establishes her claim to several lots in the Kingston townsite. According to Sophia, she not only owned land on the coroner of Pine and Iron Streets but also many other lots around the townsite. Oral history says that at age 81, she walked from Kingston to Hillsboro (eight miles) to make proof of her labor on a mining claim and returned the same day on foot. (Above, courtesy of Hillsboro Historical Society.)

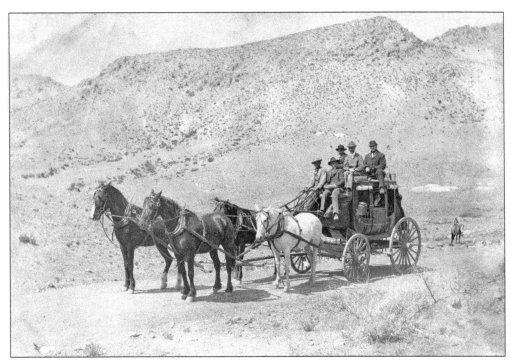

Railroads did not eliminate the need for freight wagons and stage lines in the Black Range. The Lake Valley, Hillsboro & Kingston Stage Line accessed the rough and rugged terrain of the Black Range where the railroad could not go. The stage line called the Mountain Pride was owned by James "Henry" Orchard. Above, driver William Reay holds the reigns of the Mountain Pride stage near Jarlosa Springs Station, where the stage kept a corral of horses. The round-trip ride from Lake Valley to Hillsboro cost $3.50 in 1900. Oral history claims that the infamous Sadie Orchard, at one time married to Henry Orchard, would sometimes drive the stage. However, one longtime resident said she was never seen driving the stage. Below is the Lake Valley train depot. (Both, courtesy of Merry Jo Fahl.)

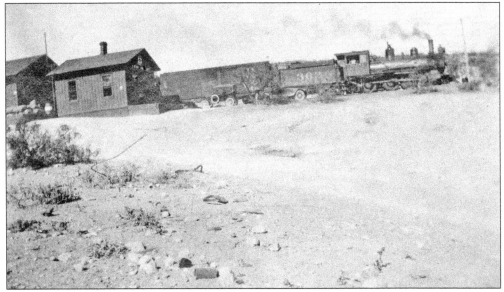

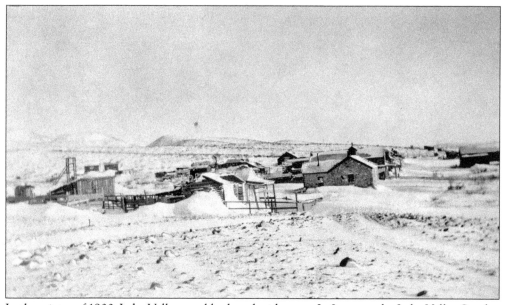

In the winter of 1900, Lake Valley was blanketed with snow. In January, the Lake Valley Sunday train was discontinued. The train continued to run Monday through Saturday. Having turned 84, Patrick Gill, an old soldier who lived in Lake Valley, was taken to the "Soldier's Home" near Los Angeles, California. He could no longer live by himself. (Courtesy of Merry Jo Fahl.)

This enginehouse on a Mrs. Green's property was used to pump water from the lake at Lake Valley in the days when water was hauled into the town. During World War II, Lake Valley had a slight revival when manganese, the cover rock over silver deposits, was needed to harden steel. Manganese piles were all over Lake Valley, above- and belowground. (Courtesy of Merry Jo Fahl.)

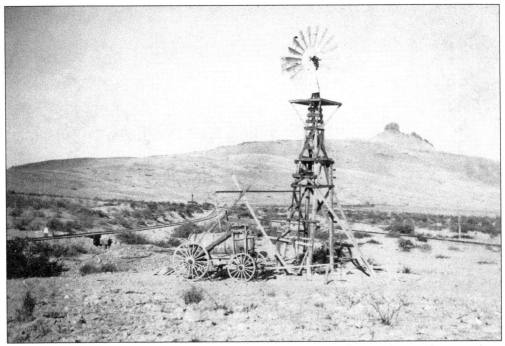

At one time, Lake Valley received its water through a pumping machine and pipes, shown in these photographs. The water was pumped from the nearby lake. The picture above shows Monument Peak, also known as Lizard Mountain due to the appearance of a lizard climbing up the side of the mountain. Monument Peak was at one time one of several peaks in the state by which mirror heliograph telegraphs (a visual telegraph for sending and receiving messages by means of mirrors and sunlight) were sent from El Paso, Texas (Fort Bliss) to Fort McRae (in New Mexico), a distance of about 150 miles. By 1920, heliographs were the most useful communication device available for the US Forest Service. (Both, courtesy of Merry Jo Fahl.)

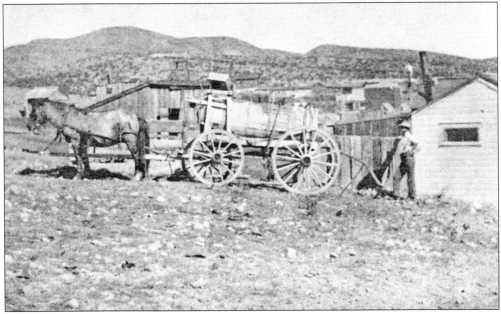

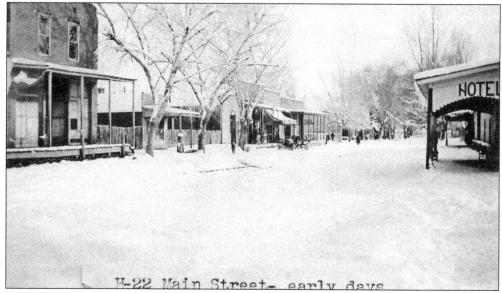

According to the May 10, 1907, issue of the *Sierra County Advocate*, Dr. F.I. Given of Hillsboro was suspicious about the death of Manuel Madrid, so he informed the Sierra County district attorney, H.A. Wolford, who promptly commenced a "vigorous investigation." A coroner's jury was called, and Alma Lyons made a partial confession that led to her arrest and the arrest of two other individuals, Valentina Madrid and Francisco Baca.

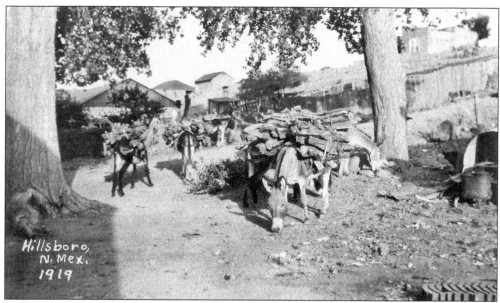

In 1917, Henry Ford entered the truck business with a one-ton-rated Ford Model TT chassis. Despite such progress, woodsmen such as Cruz Montoya continued to cart wood up the steep embankment of Hillsboro on the backs of burros. The Sierra County Courthouse can be seen at the top of the hill.

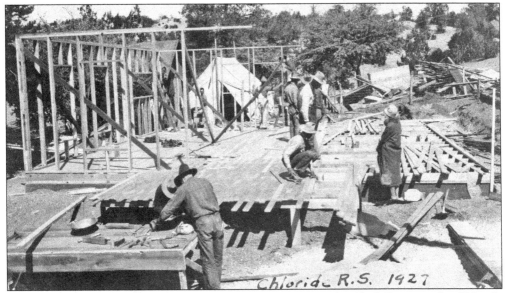

In 1927, rangers are working on a new forest ranger station in the Black Range in the Chloride area. In November of that year, 40 forest rangers led the search for a Deming High School boy, Montgomery Armstrong. Armstrong had been missing from his hunting camp for several days. Forty-one National Guardsmen were available if needed to help in the search. Armstrong actually wandered upon some cowboys on the Diamond Bar Ranch four days later, and they took him to the ranch headquarters. (Courtesy of John Wilks.)

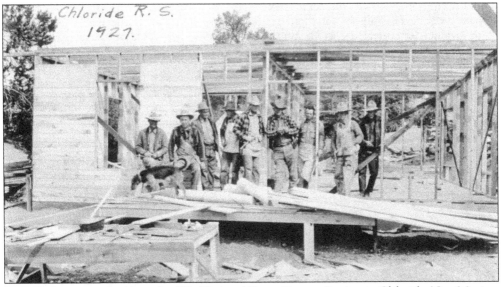

In 1927, the rangers building the Gila National Forest Ranger Station in Chloride, New Mexico, pose for a picture. The Black Range Mountains lie entirely within Gila National Forest. Many of the men who worked in the forest during their time with the Civilian Conservation Corps (CCC) returned to work in careers with the US Forest Service. (Courtesy of John Wilks.)

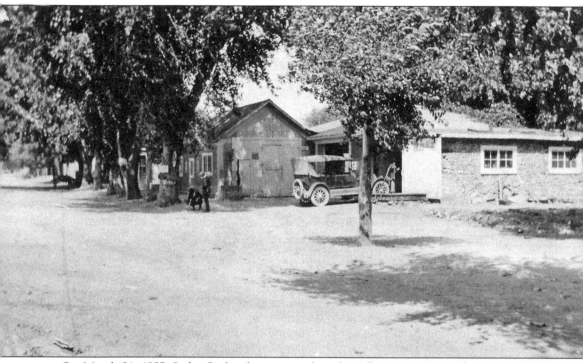

On March 31, 1937, Sadie Orchard was quoted in the *Albuquerque Journal* as opposing the movement to switch the county seat from Hillsboro to Hot Springs. Sadie, along with Mrs. C.G. Grion, Ed Grion, and E.D. Tittmann, all of Hillsboro, were the plaintiffs opposing the Board of County Commissioners of Sierra County—Leo F. Smith, Ove E. Overson, and Earl E. Stiles. Sadie fought hard to keep the county seat at Hillsboro. Despite the fight, the seat was moved to Hot Springs in 1938, and the courthouse in Hillsboro was torn down, its materials sold for salvage. Sadie died in Hillsboro on April 3, 1943, after spending the last several years of her life as an invalid. Her funeral cost $150, and the informant on her record of funeral was Dr. A.C. White from Hot Springs. Sadie died 59 years to the day after Sierra County was created. This photograph shows Hillsboro in the 1930s.

Four

LITTLE TOWNS WITH BIG HISTORIES

Those in this c. early-1900s studio photograph are identified as the wedding party of V.G. Trujillo. The men are wearing suits with boutonnieres. The studio has a painted backdrop in front of which the wedding party poses. V.G. Trujillo was said to hold a number of posts in the area, including chairman of the Board of Sierra County Commissioners. (Courtesy of CSWR, UNM 000-179-0629.)

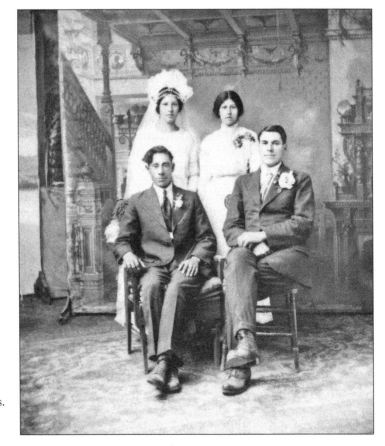

Monticello Canyon, with its perpetual spring water and wildlife, was viewed by Apache chief Victorio as both his homeland and birthright. Because of floods and Indian raids, many residents abandoned San Ignacio de la Alamosa and moved up Alamosa Creek valley between 1862 and 1866, establishing Cañada Alamosa, which was also simply called Alamosa. The first land claim was established by Isidrio Barreros, with J.D. Emmerson also considered as an early founder of the town. According to longtime resident Ramon Montoya of Hot Springs and written in his own hand (some of the names are hard to read and may be misspelled), the 13 original families who settled Cañada Alamosa were Juan Montoya, Yoco Lionado Torres, Bentura Trujillo, Jose Trujillo, Manuel Torres, Juan Lucero, Bernabal Chavez, Carpio Barela, Tomas Montoya, Jose de Jesus Garcia, Gregorio Sedillo, Besente Sedillo, and Lewis Ensinia. In 1881, Cañada Alamosa was renamed Monticello after John Sullivan's hometown. Sullivan was a soldier living in Alamosita when the 1870 census was taken, and by 1880, he was listed as a freighter. (Courtesy of Sherry Fletcher.)

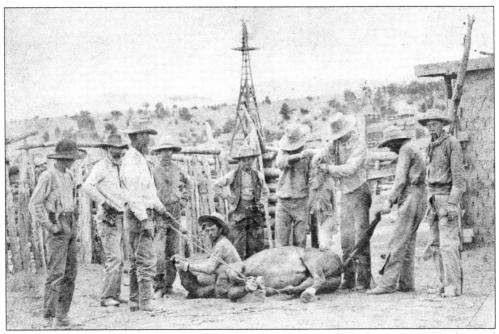

In 1884, Texan Hiram Allen brought a small bunch of cattle and a bad reputation. He shot and killed Buck Powell in Meyer's Saloon in Fairview (later renamed Winston). Allen got 50 years in the penitentiary. Apaches also terrorized citizens as settlers moving in continued to try to move the Indians out. Cowboys are pictured branding a horse at the Blun R. Ranch near Fairview.

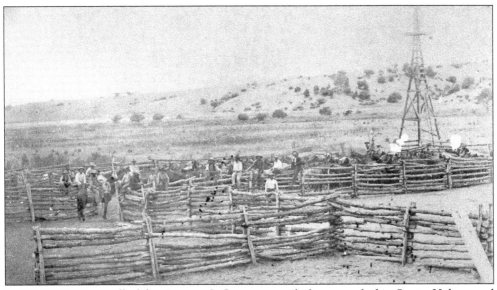

In 1884, W.S. Hopewell of the Grayson & Company cattle firm came before Squire Holmes and swore out a warrant against Besillo Chavez, owner of a ranch below Fairview on the Cuchillo Negro Creek. He claimed that Chavez butchered one of the Grayson cattle, cutting the brand from the hide and burying it. The photograph shows a ranch roundup taking place just above Fairview.

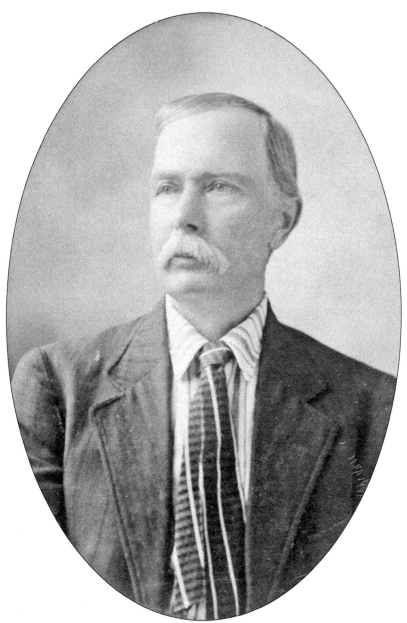

Frank Winston was appointed the postmaster of Grafton, New Mexico, on February 21, 1884. Winston, born in Wisconsin, was a retail merchant who served in the New Mexico Territorial Legislature, formed the Fairview Cattle Company, and established and ran the Frank H. Winston and Company Mercantile in Fairview, New Mexico. His generosity to the townsfolk of Fairview was widely known. He was known to give credit to many of the residents after the mines failed in the 1890s. Those who were heavily in debt to Winston simply left their property to him when they died. Rather than using the proceeds from these properties for personal profit, Winston used the money to continue restocking his store. The 1930 US Census still lists the town of Fairview. However, in 1930, after Winston's death, residents changed the name of the town to Winston to honor their friend. There were 182 residents listed in Fairview in 1930, with most occupations listed in the census as working in the woodyard or sawmill and as stock raisers (ranchers).

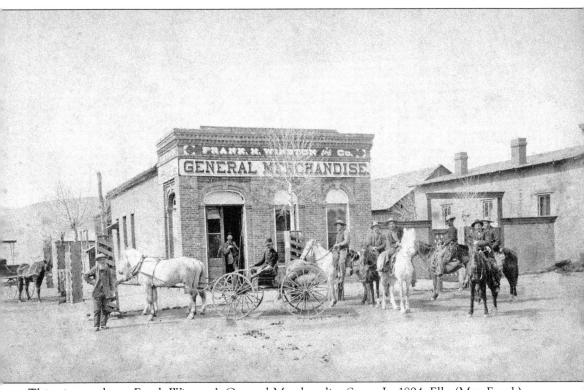

This picture shows Frank Winston's General Merchandise Store. In 1894, Ella (Mrs. Frank) Winston's brother, George Walden, died at her home. Walden was a victim of the dreaded disease tuberculosis. It was called "consumption" because it seemed to consume a person. Walden was 27 years old and unmarried. He had only been living with his sister for a couple of months. The funeral service was held at the home of his sister in Fairview, with Charles Russell conducting the services. The remains were taken to the Chloride Cemetery, where Walden was laid to rest. Although the territory of New Mexico was seen as a good place for TB sufferers, called "lungers," to come to due to the abundant fresh air and sunshine, there had been no hope for Walden. It was only when streptomycin became available in 1949 that the spread of the disease could be controlled.

In 1894, Thomas Scales announced that his Black Range Smelting & Mining Company was going to erect a reduction plant at Fairview. He planned on putting up a 40-ton copper matte stack on the 20 acres he had bought from a Mr. Olney at a site just below Fairview. The new plant was to be built on the site of the old smelter. That same year, Thomas Scales and his wife, shown here, celebrated their silver wedding anniversary. Sixty or so guests were there to help with the celebration, which was held at the Cantwell dwelling. Songs were sung and recitations given by local talent Eva Crawford and the Honorable A.F. Childs. Presents received by the couple included a jewelry holder from Mr. and Mrs. Benjamin Cook, a set of silver forks from Mr. and Mrs. Frank Winston, sterling silver souvenir spoons from Sadie Stailey and friends, a tea tray from Mrs. S.E. Corson, and a solid silver brick from August Mayer.

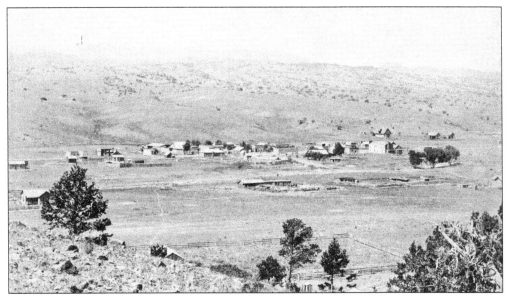

Oral history says that Buena Vista was founded in 1881, just after Harry Pye's silver discovery in Chloride. It sat in a beautiful valley filled with grasslands and surrounded by mountains. Apaches were said to frequent the valley. The name *Fairview* was an English translation of the Spanish name *Buena Vista*. It would become a very valuable distributing post for the entire region. This photograph shows the town after its name was changed to Winston.

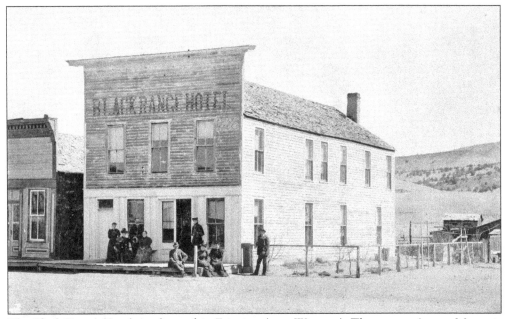

The Black Range Hotel was located in Fairview (now Winston). The owner, August Mayer, is shown standing alone by the fence. His daughter, Pauline, stands by the door, and Mrs. Henry Schmidt is identified as the woman sitting with the hat. The dance hall on the left was used until the 1920s.

Pedro Chavez of Fairview is shown at left around 1890 to 1909. The 1910 census lists a Pedro Chavez who, at age 63, worked as a laborer doing odd jobs. By 1910, Fairview had only one hotel, and it was run by a local man, Harry Reilly. (Courtesy of CSWR, UNM 000-179-0337.)

Mrs. Pedro Chavez of Fairview poses for a picture taken anywhere from 1910 to 1924. In 1910, Fairview had a Western-style shoot-up. William "Smokey" Chisholm, with a six-shooter in each hand and a belt full of cartridges, shot up the town. Smokey would be held in the county jail until being turned over to a grand jury. (Courtesy of CSWR, UNM 000-179-0139.)

As the forts closed and mining decreased, residents moved on, and Monticello became much smaller. Alphonse Bourquet owned a store in the 1900s that sold boots, hats, native wines, and other general merchandise. On September 19, 1881, the post office opened at Monticello and Aristide Bourquet was appointed the first postmaster. (Courtesy of Sherry Fletcher.)

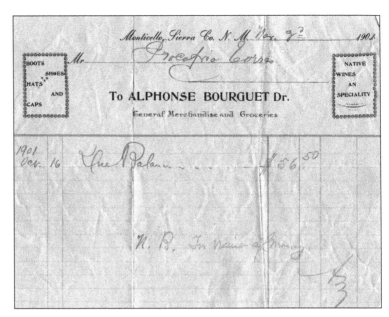

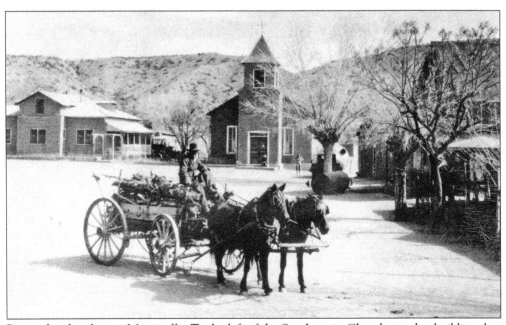

Pictured is the plaza in Monticello. To the left of the San Ignacio Church stands a building that was originally a monastery built to serve as a place of residence for priests who served in the parish. The man in the wagon is identified as Casamiro Ramirez.

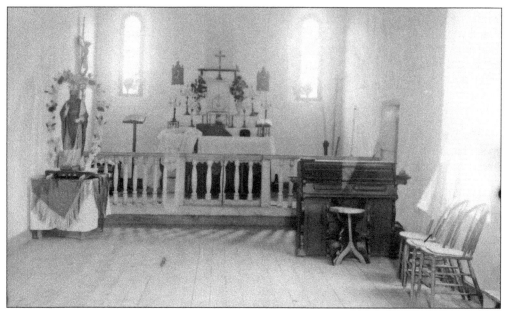

Cañada Alamosa was made up of long, narrow farms that followed an irrigation ditch. The buildings were constructed along the road, and the community church stood in the plaza. This picture shows the interior of the Monticello Church, which sat on the plaza in downtown Cañada Alamosa, later renamed Monticello. (Courtesy of CSWR, UNM 000-179-0857.)

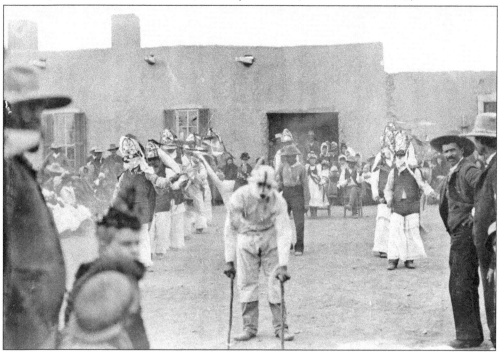

In the 1880 US census, there were 274 residents in Cañada Alamosa, with 91 percent being native New Mexicans. Most adult males were farmers or farm laborers. There was one store clerk listed, one Catholic priest, and a handful of US soldiers. A Monticello Church festival is pictured here. (Courtesy of CSWR, UNM 000-179-0677.)

Pictured at right are Cornelius Sullivan, his wife, Susan, and "Sister." In 1903, Cornelius and his family were living in Monticello, New Mexico. Driving to their ranch in a wagon, Susan held her daughter Ethel in her arms. Susan's son, Ira, and her father, Joseph Hensley, were also in the wagon. Cornelius and a friend followed on horseback. Heavy rains had compromised the bank, and the wagon overturned. Susan was crushed under the horses while trying to save the lives of her children. She died a couple of days later, a distraught Cornelius by her side. Susan is buried in Monticello with a shamrock engraved on her headstone. Shown below are Ethel and Ira as older children. (Both, courtesy of Charles and Bobbie Sullivan.)

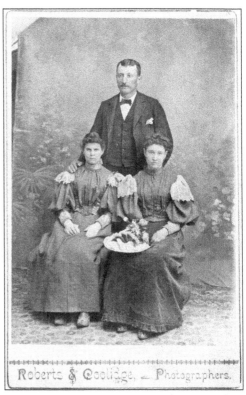

Roberts & Coolidge, Photographers.

The Stone Ranch Bluffs sit at the crossroads to the villages of Chiz and Hermosa. Oral history says that Chiz, located at the headwaters of the Cuchillo Negro Creek, was named after Indian chieftain Cochise (also known as Cheis or Chis), whose name is Apache for "oak." The farm of Bentura Trujillo, the largest sheep owner in the Cuchillo area in 1880, became the center of the community of Chiz.

Raymond Schmidt was photographer Henry Schmidt's son. For this photograph, it was said that he had walked over from Tyrone, New Mexico. Tyrone was in Grant County and was built by the Phelps Dodge Corporation in 1915 for more than $1 million. Raymond documented the history behind many of his father's photographs. (Courtesy of CSWR, UNM 000-179-0375.)

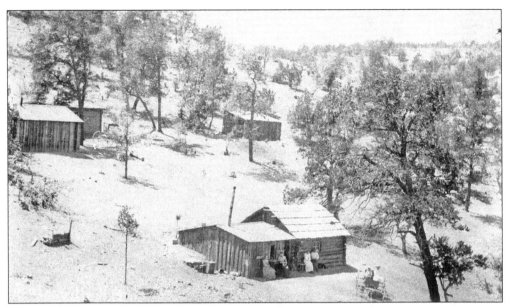

Oral history says that a group of prospectors, the "Long Nine," met around a campfire and decided to name the mining district Palomas Mining District and the town Hermosa (Spanish for "beautiful"). Another story says that the town (shown in both photographs) began in 1883 when J.C. Pelmmons brought cattle to the area and built a store and a house. Apaches were known to raid the area. Mrs. D.C. Rogers, the only white woman in Hermosa for two years, had to hide in the mine tunnel during an 11-day battle. She is credited with establishing an assay office in Grafton. The buffalo soldiers, two cavalry regiments of black soldiers, helped fight bands of Apache in southern New Mexico in the early 1880s. Some of them are buried up Animas Creek at Hermosa on the Ladder Ranch.

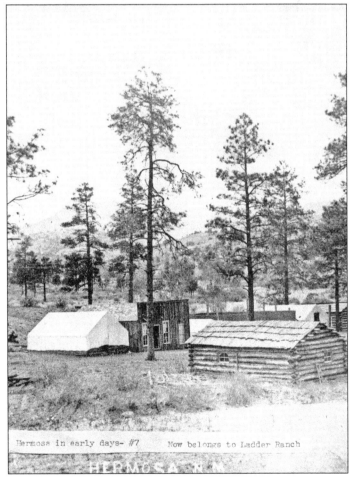

Hermosa in early days- #7 Now belongs to Ladder Ranch

HERMOSA N M

57

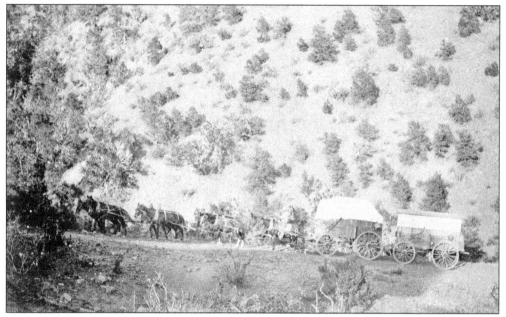

This photograph shows a freight team going from Fairview to Grafton. At the end of the stage line to Grafton, there was a hotel with a good reputation run by a Mr. Staley. The San Mateo, Alley, and Ivanhoe ranches were nearby. Grafton was the target of many Indian raids, especially by Victorio, Geronimo, and Bonito. Important mines of the area were the Ivanhoe, the Alaska, and the Occidental.

Alvaro Garcia, shown wearing a cowboy hat, vest, and driving gloves, was a stage driver in Chloride. With its headquarters in Cuchillo, the stage line ran between Engle and Chloride. It operated from 1886 until 1914. In 1902, the line was purchased from the Armstrong brothers by Robert Martin. (Courtesy of CSWR, UNM 000-179-0306.)

In 1879, mule skinner and freight hauler Harry Pye picked up silver float while working for the federal government. After his contract with the government ended, Pye and other prospectors returned to the area and found the mother lode. Pye was given credit, and the area was called the Pye Lode. The ore was chloride of silver, so the settlement was called Chloride. By 1881, the town of Chloride was established.

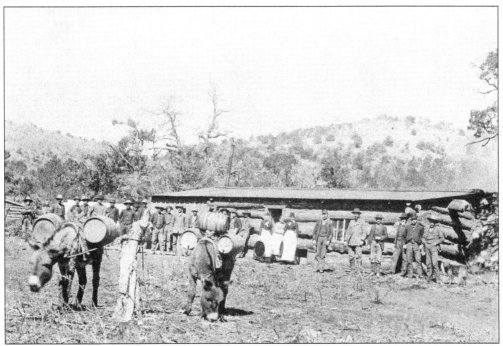

The picture above is identified as the Ingersoll Mine Camp near Chloride in the 1880s. By 1896, the construction of a 100-ton stack at the smelter in Chloride was underway. Two miles west of Chloride was the Nana mine. It was owned by the James brothers, the Armstrong brothers, and Austin Crawford.

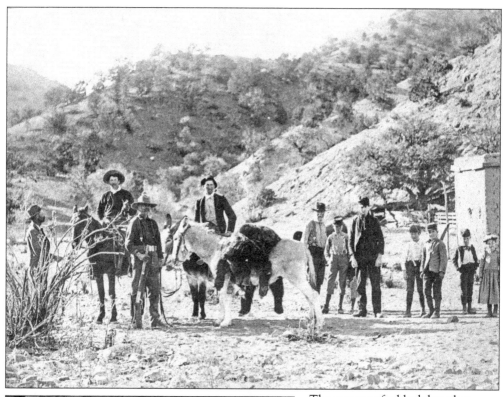

The carcass of a black bear has been tied to the back of a burro in the vicinity of Chloride. In the early 1900s, the population of black bears was significantly reduced by unlimited hunting and poisons. The New Mexico Department of Game and Fish classified black bears as a big game species in 1927, and a limit of one bear during the season (October) was imposed. (Courtesy of CSWR, UNM 000-179-0672.)

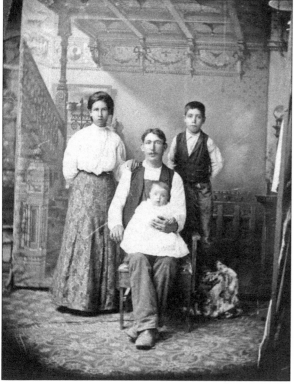

The Miranda family of Chloride is seated in Henry Schmidt's photography studio. Martin Miranda Sr. sits holding baby Higinio, who died the following year. The photograph was taken in 1909. The boy standing is unidentified. The woman is Martin's wife, Dolores. According to the Miranda family, Martin was the justice of the peace in Chloride. (Courtesy of CSWR, UNM 000-179-0558.)

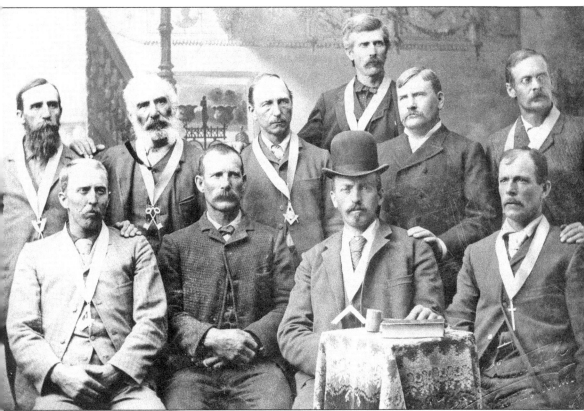

Members of the Masonic Lodge Western Star No. 14 are shown in this 1888 photograph. Two individuals can positively be identified. Chloride judge Edwin F. Holmes stands at far left in the second row, and to the far right is Dr. Elmer Philio Blinn. The other names on the picture include Henry Rickert, Bob Boulware, S.F. Mullings, Jim Gill, and Henry Cook. Dr. Blinn owned a claim on the Argonaut Mine, south of Chloride. In 1891, his talents as a physician were called upon to dress the wound of miner Alex Trudeau, who had received a bad cut on his elbow from an ax at a mine.

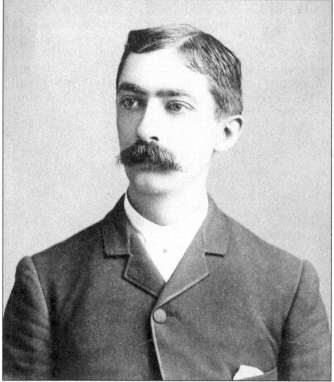

This is the assay office of Henry Schmidt in Chloride. The adobe portion of the building was built prior to the wood structure. Schmidt is credited with many early photographs of the area. Today, his collection consists of original dry-plate negatives on glass. Most of his photographs were taken around Chloride. (CSWR, UNM 000-179-0848.)

Henry Schmidt was an immigrant from Germany who settled in the Lake Valley area in 1885 and established an assay office. In 1905, seeing the need for expanding his business, he opened a second assay office in Chloride. He lived in Chloride until his death in 1929.

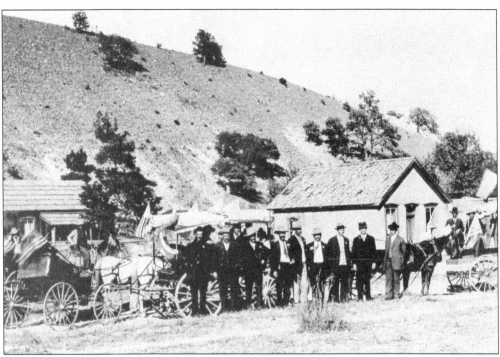

Sierra County was formed in 1884 from parts of Doña Ana, Grant, and Socorro Counties. The election delegates for Sierra County arrive in Chloride in this 1910 photograph. The home to the left belonged to Frank Calhoun. The H.O.K. Ranch, located in Cuchillo, was founded by Calhoun and operated by him until 1931, when it was sold to the H.O.K. Ranch Company.

Bears tracks from what could only be described as an extremely large black bear were seen in the area of the box canyon up by Chloride Creek in 1894. With bears in the vicinity, it is not surprising that John Fulton, identified as the man leading pack animals out of the Chloride Creek box canyon in 1894, has a rifle within easy reach.

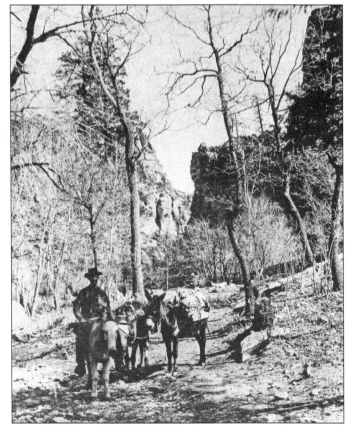

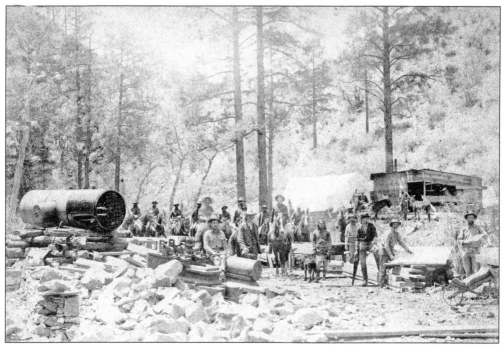

The rare photograph above shows the 10th Cavalry with Indian scouts at the Silver Monument Mine Camp in Chloride Creek, 10 miles west of the mining town of Chloride, around 1891 or 1892. The 10th Cavalry was made up of buffalo soldiers who were assigned to maintain the peace. The Apache scouts were vital to the cavalry's mission.

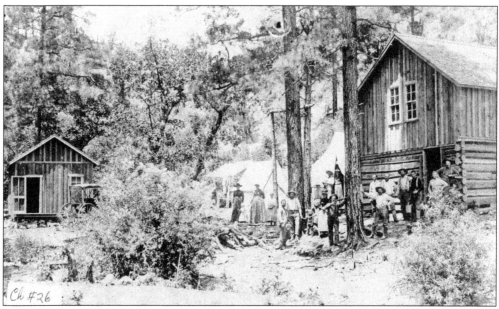

Oral history says the Silver Monument Mine was accidentally discovered when a horse and a burro tumbled down the side of the mountain, breaking off some cropping. It was bought by a St. Louis company in 1888 for the hefty sum of $50,000. The photograph shows the camp at the concentrator (a milling plant that produced a concentrate of silver) of the Silver Monument Mine.

In 1916, Fred Adams became the first appointed mayor of Hot Springs. He had the good fortune to escape death during an altercation with Indians in the area above Chloride in what became known as the Antelope Springs Massacre. Unfortunately, it was reported that his brother was killed by the Indians during the altercation.

This picture was taken at the camp of the Silver Monument Mine near Chloride. On the porch are, from left to right, Clara Hullinger, Larry Hartshorn, "Pap" Ed Davisson, Edwin Schmidt, unidentified, Charles Hullinger, Raymond Schmidt, and Amy Schmidt. By 1920, Hullinger was the superintendent of the Silver Mine Precinct and still living in Chloride.

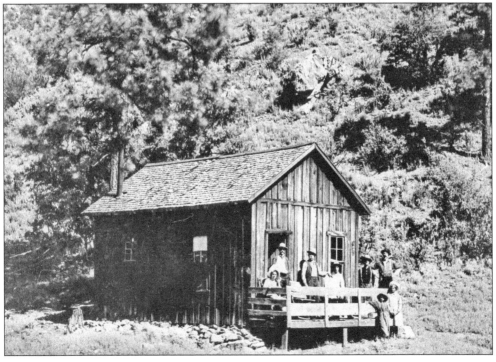

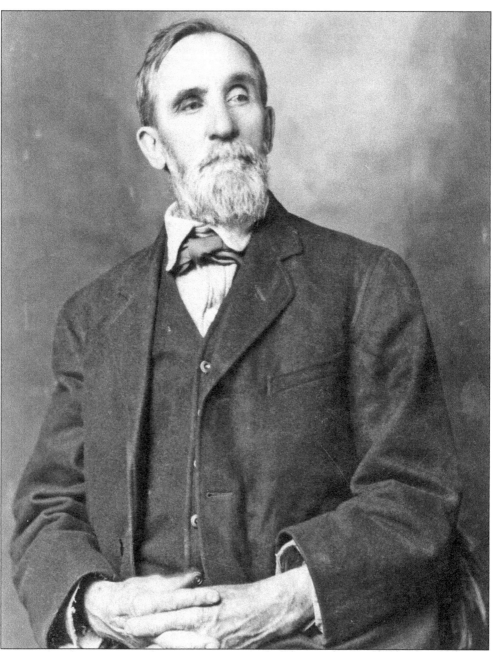

Edwin F. Holmes arrived in Chloride in 1883. He practiced law, was a justice of the peace, and had dealings in real estate. He was a member of the Masonic Lodge Western Star No. 14. The lodge was next door to the Schmidt home. Henry Schmidt, assayer and photographer, was Holmes's son in law. According to the 1910 US census, Holmes was 67 and still living in Chloride. His street address is given as "Doter Cola National Forest." He listed his occupation as a self-employed miner in the quartz mine industry. Holmes was appointed the Chloride postmaster on July 19, 1912. He continued in that position through 1916. His only pay was through the cancellation of stamps, and for one month, he said he brought home $85. Holmes died on April 4, 1922, and is buried in Chloride.

According to Howard Bryan's article "Off the Beaten Path," the Mimbreno Apache chieftain of Warm Springs was named Balshan, Apache for "knife." The Spanish translated Balshan into *cuchillo*, calling the chieftain Cuchillo Negro, or Black Knife. The town and creek of Cuchillo Negro and Cuchillo Peak all bear his name. Cuchillo Negro was killed by US troops on May 24, 1857. Oral history indicates that residents probably started occupying Cuchillo Negro around 1871. Apache trails passed through the town of Cuchillo Negro, and Cochise was said to live in peace there between 1871 and 1873. Victorio ravaged the area from 1879 through 1880. Dionicio Tafoya from Cuchillo was one of many young Sierra County men who enlisted in the Army during World War I. The photograph below shows men in the early town of Cuchillo. (Both, courtesy of Josh Bond.)

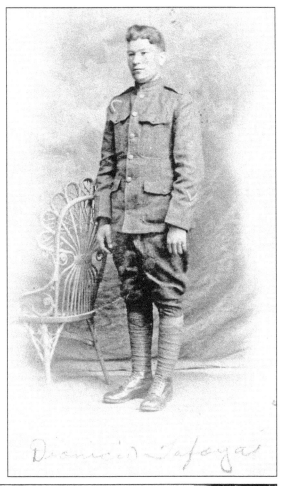

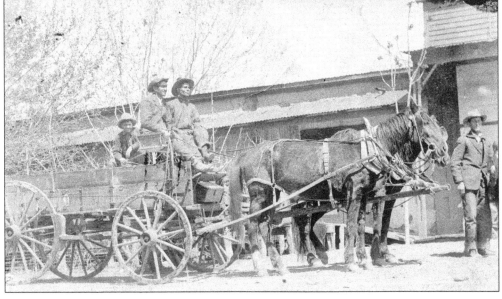

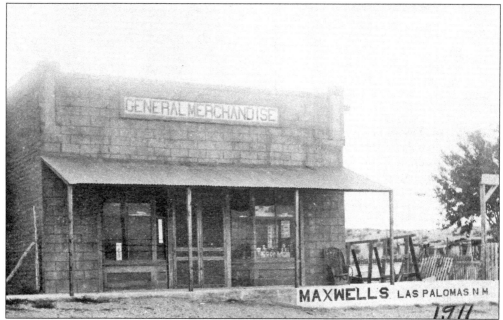

English-born Willard Samuel Hopewell and a man named Brooks moved into the Las Palomas area and homesteaded an area they called Vega Blanca, two miles south of Las Palomas. Hopewell was a successful cattleman and organized the Las Animas Cattle Company, investing $1 million in land and cattle in Sierra County. The photograph shows a general store in Las Palomas in 1911.

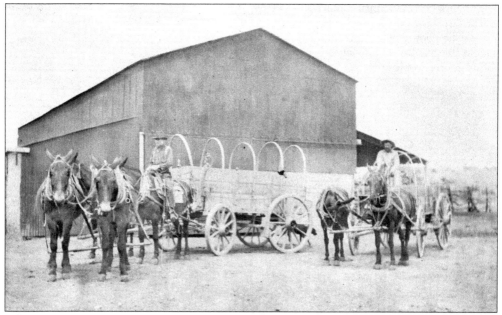

In June 1884, cattle thieves were a problem, and Las Palomas built a new jail. The *Rio Grande Republican* of June 21 notes, "The course of Mr. Hopewell and his posse with regard to the cattle thieves meets with the highest commendation from all honest men. It is hoped he will not let up in his action till they are all safely lodged in the penitentiary."

Elephant Butte Land & Cattle Company encouraged individuals to homestead land and then sell it back to the company. In 1891, Tomas Baca and Urbano Arrey, two men from Las Palomas, applied for a 160-acre homestead but with no intentions of selling their land back to the Elephant Butte Land & Cattle Company. They intended to raise their families in the community called El Bonito (seen here), Spanish for "pretty."

The first post office in El Bonito was established in 1909, and Urbano Arrey became the first postmaster. That same year, the town's name was changed from El Bonito to Arrey in honor of Urbano. In June 1892, Mr. and Mrs. Eufemio Grijalva had Simon, the first baby in the community of Arrey. This young man is pictured on the first school bus in Arrey.

In 1881, a tent city known as Gold Dust was about four miles northeast of Hillsboro. It had the unfavorable reputation of having once been attacked by Victorio and a band of Apaches. Favorably, it appeared that there were no causalities. Ranching developed in the area. This photograph shows Gold Dust in 1927.

The town of Cutter (shown in later days as a ghost town) was seven miles south of Engel and 17 miles from Hot Springs. It started as a station for the Santa Fe Railway and a shipping point for Black Range ore. It boomed during the area's mining days, which included the mining of vanadium, lead, and copper from the nearby Caballo Mountains. The Victoria Chief Copper Mining Company started a mill in the area.

— we , the undersigned , Coroner's Jury in the inquest over

the remains of Wilbert Leach, held by the order and under the

direction of Estanislado Armijo, Depety Cononer of Las Palomas,

Sierra County, New Mexico; find: that Wilbert Leach came to his

death on Sunday April 28, 1907, in the Caballo Mountains, by the

accidantal discharge of his own revolver, causing a wound in the

left breast, by falling from an open holster.

This on Monday April 29, 1907, in Copper Camp of The

Victoria Chief Copper Mining & Smelting Co.

Henry Weitzing Pres.
George W. Moore. Sec.

Harold I. Brosious.

Antonio Saladilles

Jesus M Garcia
Victorio Y Turrietta

Estanislodo Armijo

Wilbert Leach, a prospector who also worked for the Victoria Chief Copper Mining and Smelting Company as a carpenter, had gone prospecting with a Mr. Sheley and W.W. Barracks in the Caballo Mountains in 1907. According to the testimony of Barracks, he and Sheley left Leach building a monument of rocks and went 1,500 feet away. When Leach did not show up, Sheley went back first and then got Barracks. They found Leach lying on his face with his revolver on a rock near him, one chamber empty. Leach never responded. He had a gunshot to the breast where a blood clot had formed, and another wound was visible on his back, indicating that the bullet had gone through his chest area and out his back. The coroner's jury found Leach's death in the Caballo Mountains to be "by the accidental discharge of his own revolver, causing a wound in the left breast, by falling from an open holster." They thought the gun slipped from its scabbard while Leach was stooping over to pick up stones while building his monument.

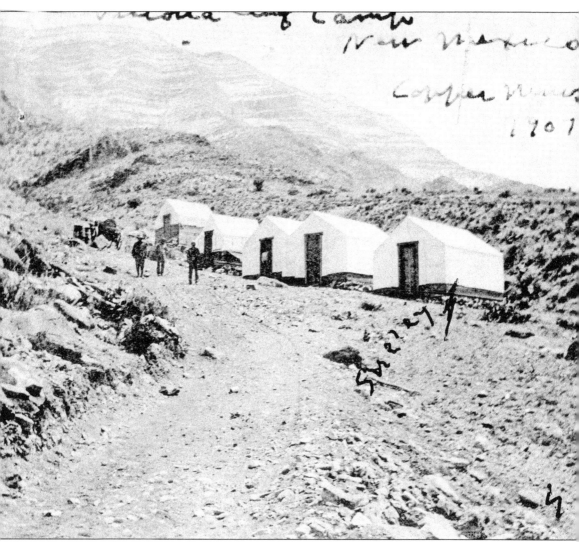

The Victoria Chief Copper Mining Company camp, located in the Caballo Mountains, is shown here in 1907. The mining company's mill employed about 300 men. The company also built a two-story brick hotel in Cutter that housed the First National Bank, a store, a restaurant, and the post office. The town was also home to railroad employees. Cutter had a lumberyard, five saloons, and a livery stable. Students from grades one through eight attended a one-room schoolhouse built by the mining company. The closing of the mines and railroad led to the end of Cutter. It was said that the Victoria Chief Copper Mining and Smelting Company was originally organized by Robert H. Hopper and Julia Bigelow, who also promoted other mines in Sierra County. (Courtesy of Merry Jo Fahl.)

Five

HOT SPRINGS, MIRACLE WATER, AND DAMS

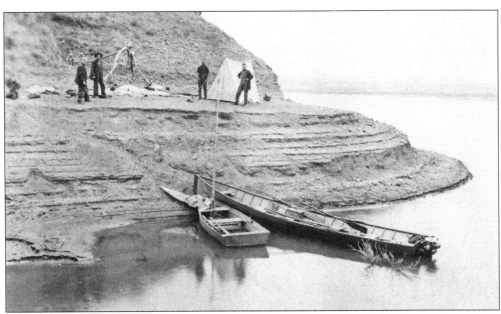

This photograph shows a hunting party at its camp on Elephant Butte Lake in early times. In 1915, Doña Ana County commissioner J. Findlay asked the president of the Elephant Butte User's Association to recommend to the US secretary of the interior that the lake created by the construction of the Elephant Butte Dam be named Lake Boyd, after Dr. Nathan Boyd. It did not happen, of course. (Courtesy of Mary Moyers.)

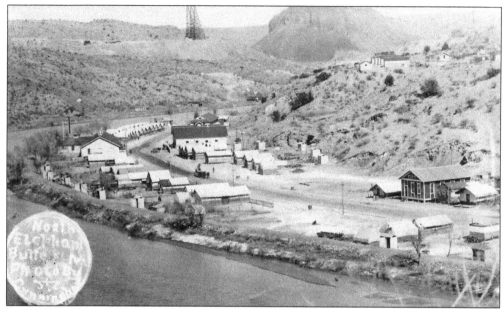

Elephant Butte Dam, part of the Rio Grande Project to help control flooding in the Rio Grande valley, also helped to fulfill a 1906 treaty between the United States and Mexico on the distribution of water from the river. The dam was the first engineering structure ever built to settle an international dispute. The construction camp in 1912 is pictured.

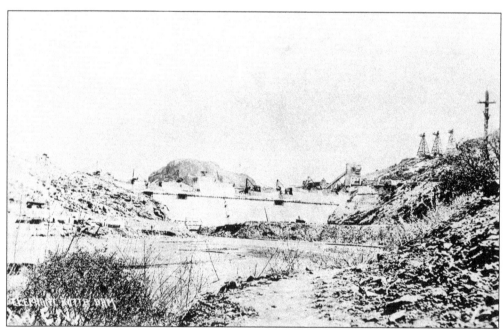

By 1914, there were said to be 1,500 men working eight-hour shifts in the construction of Elephant Butte Dam. Eventually, electric lights were installed so that crews could work through the night. Elephant Butte was one of the last gravity dams ever built. It was literally the sheer weight of the dam that held the entire structure in place. (Courtesy of Merry Jo Fahl.)

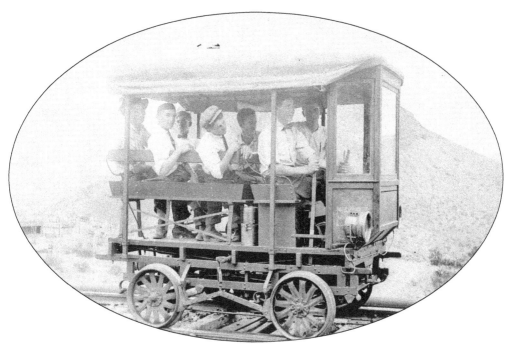

This motor car ran on train tracks and was used between Elephant Butte and the main railroad line. The branch railway from the town of Engle to the damsite allowed carloads of supplies and materials to be delivered to the damsite. The laborers who worked in various departments around the camp were known as a gang (for "construction gang"). (Courtesy of Merry Jo Fahl.)

Controversy over the government using illegal aliens as workers on the dam was investigated by Frederick H. Newell, director of the US Reclamation Service. Newell noted any person claiming American citizenship was welcome to work and emphasized that it did not matter if they spoke English or not. He said there was no discrimination in that the government had used local labor as much as possible. As noted by the "Mexican camp," discrimination occurred.

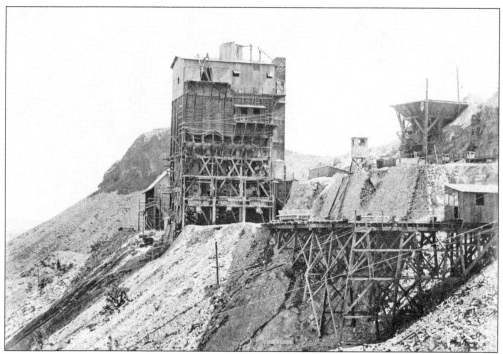

The concrete mixing plant shown had an average daily capacity of 240 cubic yards of cement in eight hours. Cyclopean rubble concrete was used in the construction of the Elephant Butte Dam. To take care of the expansion, temperature fluctuations, and cracking in the dam, every other column was poured with cement, and columns in between were poured in 20-foot-lifts with a heavy oil coating between them.

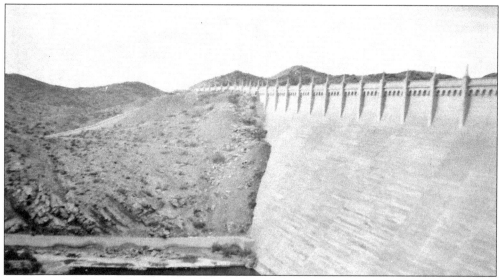

At the top left of this photograph is the dam's spillway. A.A. Jones stood on a platform built over the spillway as Pres. Woodrow Wilson's representative on October 19, 1916, addressing the 350 delegates from the International Irrigation Congress, the International Farm Congress, and other guests who lined the banks of the Elephant Butte Lake or stood on top of the concrete dam. (Courtesy of Mary Moyers.)

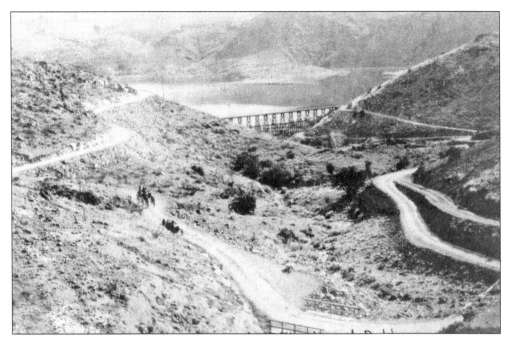

This picture shows the horseshoe curves across what was known as Hospital Canyon. The railroad bridge and Elephant Butte Lake are in the distance. In March 1916, Pancho Villa crossed into the United States and attacked the town of Columbus, New Mexico. The New Mexico Guard was sent to guard Elephant Butte Dam due to rumors that dam was going to be dynamited.

The dam was often referred to in the papers as Engle Dam. On March 15, 1917, the *Santa Fe New Mexican* ran the headline "Heavy Guard for Engle Dam." The United States had severed relations with Germany, and suspicion was high that the Germans might blow the dam up. It had been said that two Germans had passed through the nearby town of Engle. (Courtesy of Mary Moyers.)

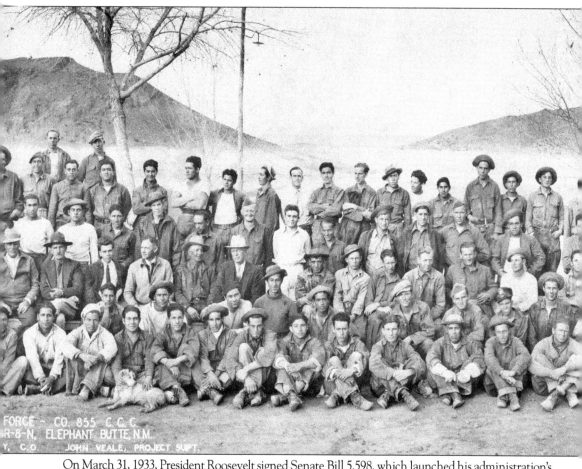

FORCE - CO. 855 C.C.C.
R-8-N, ELEPHANT BUTTE, N.M.
Y, C.O. JOHN VEALE, PROJECT SUPT.

On March 31, 1933, President Roosevelt signed Senate Bill 5.598, which launched his administration's New Deal relief programs. The purpose was to save "two of the nation's wasted resources, the young men and the land." One of the programs was the Civilian Conservation Corps (CCC). In the beginning of the CCC, enrollees had to be between the ages of 17 and 25, US citizens, unmarried, out of school, unemployed, between five feet and six feet, six inches tall, weigh at least 107 pounds, have several family dependents, satisfy certain minimal health and dental requirements, agree to serve at least six months, and agree to have the major part of their earnings sent home to their families. There were two CCC camps built at Elephant Butte. The first one, BR-8-N, is pictured here and became operational in the fall of 1934. An educational advisor at the BR-8-N camp provided courses for students in arithmetic, auto mechanics, civil service, English, first aid, lifesaving, penmanship, photography, physical culture, hygiene, spelling, topography, typing, woodworking, leather and metalcraft, and cabinet building.

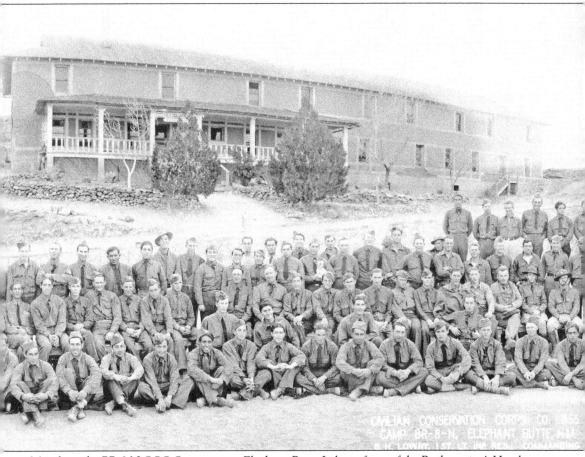

CIVILIAN CONSERVATION CORPS CO. 855
CAMP BR-8-N, ELEPHANT BUTTE, N.M.
B. H. LOWRY, 1ST. LT. INF. RES. COMMANDING

Men from the BR-8-N CCC Camp pose at Elephant Butte Lake in front of the Reclamation's Hotel. When the photograph was taken, the hotel was the CCC camp headquarters. In 1938, complaints in the local newspapers said that a hotel had been built on Elephant Butte Lake but there had been little done to keep up the place. Editorials noted that the CCC had been working at places like Carlsbad Caverns, White Sands, and other spots around the state, but little had been done at Elephant Butte Lake. Particularly annoying was the lack of shade trees in the scorching heat. This photograph, however, clearly indicates that the CCC was going to do some fabulous things around Elephant Butte Lake. Its work stands today in the form of stone structures throughout the lake. Stone, of course, was much more prevalent in the area than wood. The CCC planted and landscaped and built comfort stations, pavilions, fireplaces, table and bench combinations, tourist camps, and a new fish hatchery. It also built 15 tourist cabins at the damsite.

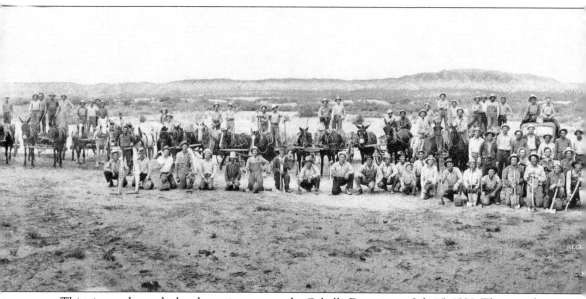

This picture shows the brush-cutting gang at the Caballo Dam site on July 15, 1938. These workers were part of the CCC camp at Caballo Dam. Work was scarce because of the Great Depression, so when several hundred men were hired to clear the brush and timber from the reservoir by hand, it helped many individuals living in the valley. These men were also called upon to help

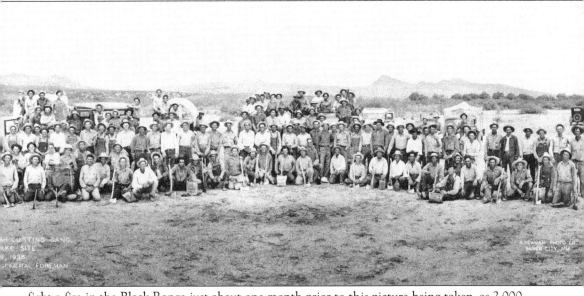

fight a fire in the Black Range just about one month prior to this picture being taken, as 2,000 acres of timberland had already been burned and the fire was still out of control. (Courtesy of the Hatch Museum.)

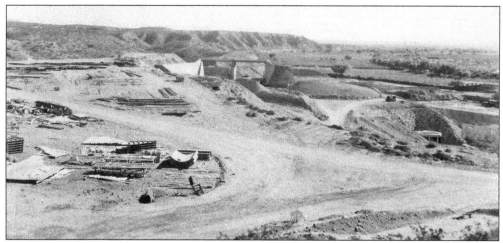

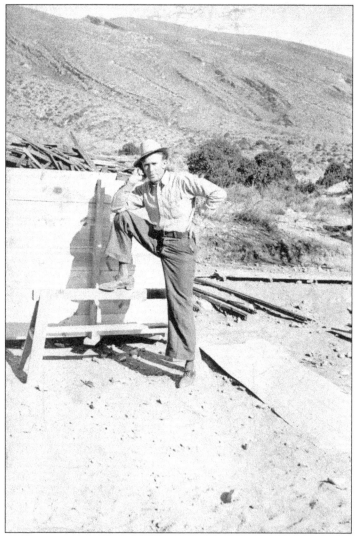

Caballo Dam was built to provide flood protection for the projects downstream, stabilize outflows from Elephant Butte, and replace storage lost in Elephant Butte Reservoir due to sedimentation. With the benefit of flow regulation, a small hydroelectric plant was completed in 1940 at the base of Elephant Butte Dam, providing electricity not only to farmers but also to residents of the county.

Horace Albert "Doc" Witt was born in 1905 in Missouri. He got his nickname by supposedly selling liquor in medicine bottles throughout the Ozark Mountains. Witt played amateur baseball and the guitar. He came to New Mexico in the early 1930s and help to build the campsite that served the workers of the Caballo Dam CCC crew. Witt loved fishing at Elephant Butte Lake.

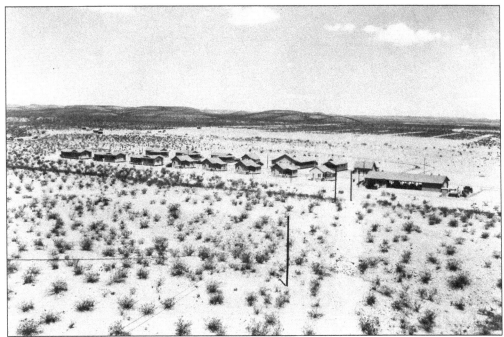

These pictures show the camp where the CCC worked at Caballo Dam in Sierra County. Originally, men had to be within the ages of 17 and 25, but this was later changed to 18 to 28. Then, employment opportunities were given to older men in their communities called LEMS (local experienced men). They helped not only to train and supervise the younger enrollees but also to provide them with role models. This significantly helped to reduce the number of unemployed men in Sierra County and also gave a boost to the local economy. Just building the camps helped to give jobs to individuals in Sierra County and also in nearby areas.

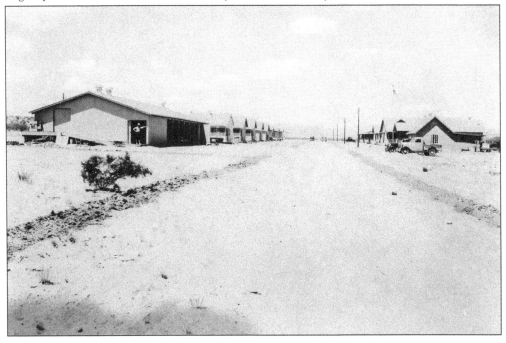

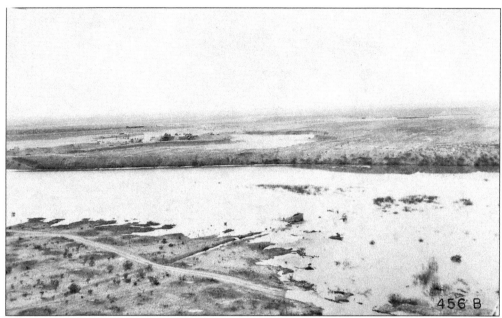

456 B

The building of the Caballo Dam 15 miles from Hot Springs (later renamed Truth or Consequences) and 25 miles downstream from Elephant Butte was the last major component of the Rio Grande Project. Devastating summer floods of 1925 hit the Rio Grande valley hard, and farmers asked the US Bureau of Reclamation for a second dam to help with flood control. Construction began in 1935. Early discussion was to build a power plant at Caballo Dam instead of Elephant Butte Dam. However, it was reasoned that in order to insure a continual operation of a power plant at Caballo Dam, there would have to be a constant withdrawal of water from irrigation purposes. It was said that this was out of the question, because there was insufficient withdrawal possible at water levels that could be maintained in the lower dam.

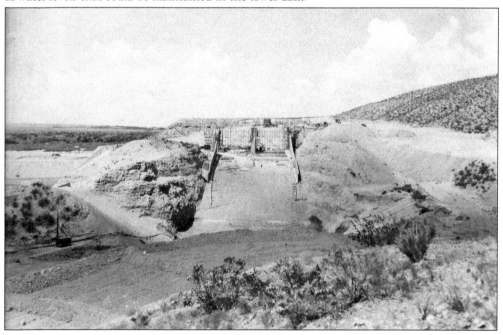

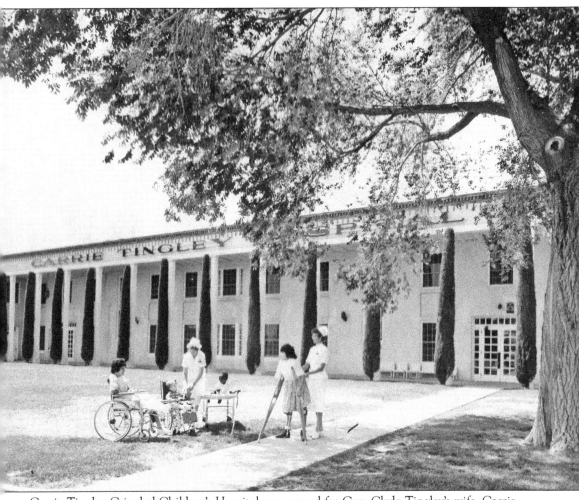

Carrie Tingley Crippled Children's Hospital was named for Gov. Clyde Tingley's wife, Carrie. Governor Tingley said, "We're going to cure a thousand of the 1,200 crippled kids in New Mexico. I can tell you this because I have a list of every crippled kid in New Mexico under 16 [years of age] on my desk, where they live and what's wrong with them." Governor Tingley told audiences, "I figured that since we had 700 convicts and a brick plant we would make the brick ourselves, so we did and I marked it off the state's books." The first concrete was poured on March 13, 1936, on property deeded to the state by the Town of Hot Springs. Hot Springs supplied a tested hot mineral well at the cost of $750 to the project, along with electricity and water for the construction.

Carrie Tingley Crippled Children's Hospital was located in Hot Springs due to the existence of hot mineral water available in underground springs in the area. Polio was at its peak in the 1940s and 1950s. It was said to paralyze or kill over 500,000 people worldwide each year. Children were especially vulnerable.

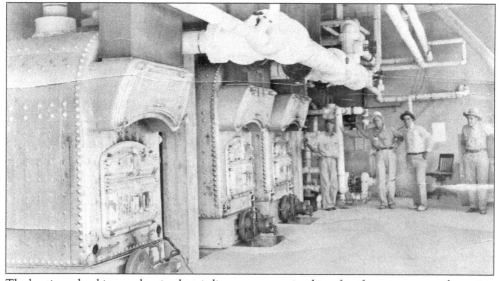

The heating, plumbing, and main electric lines were contained in a four-foot-square tunnel running three-quarters of a mile in length under the hospital. This photograph shows the boiler room under the hospital. The man in the large hat is Joe Allsup. The other individuals are not identified.

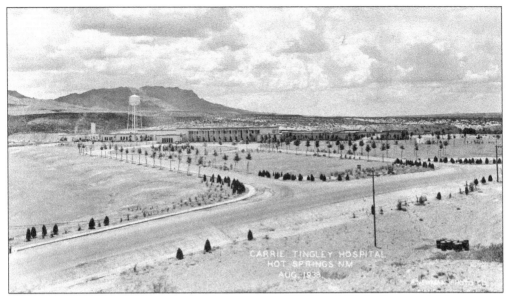

In April 1937, twenty National Youth Administration (NYA) and Works Progress Administration (WPA) seamstresses worked in Hot Springs at their sewing machines to turn 500 yards of checked muslin into child-sized night garments. Also in April, first assistant postmaster general Ambrose O'Connell came from Washington to help Gov. Clyde Tingley plant the first 200 trees on the grounds of the hospital.

Carrie Tingley Crippled Children's Hospital was officially dedicated on September 19, 1937. Hot Springs mayor A.J. Burleson asked businesses to participate in the festivities. Governor Tingley led a parade through the town and then spoke in front of the hospital, where an estimated 5,000 people waited. Even before the dedication, there were 33 patients at the hospital, and not all were children.

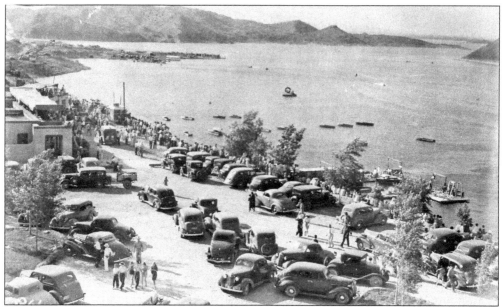

The Elephant Butte Regatta of 1936 was composed of speedboat races, diving events, swimming events, bathing girls, softball games, and other attractions. Silver cups, $500 in cash, and merchandise went to the winners in the various events. All of the winners from that year were from out of state. The previous year had attracted 87 cars, three buses, and 398 people to the event. James "Jim" Knox, onetime owner of the Vera Hotel, was said to be instrumental in bringing the regatta to Elephant Butte. In 1936, Gov. Clyde Tingley was the honorary chairman. Speedboat racers from around the world came to compete in the annual event. The ninth annual regatta was held in 1939. A printed program helped to advertise the businesses that were said to "help make it a better show every year."

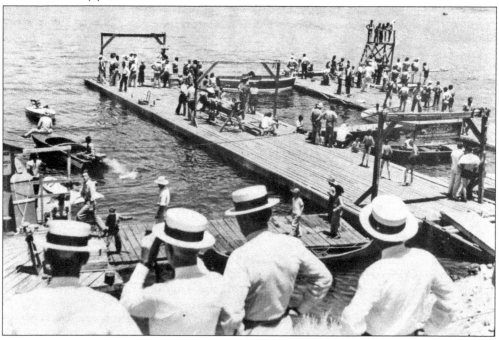

Six

WOOL, CATTLE, AND LAND

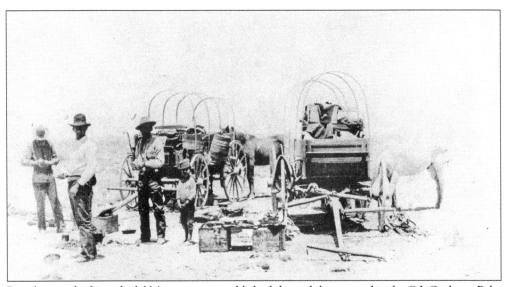

Ranches on the Jornada del Muerto were established through homesteading by C.J. Graham, Poke Armstrong, Hiram Yoast, and ? Putman. This area was classified as open range, enabling free movement of cattle by ranch owners in the 1890s. In 1900, drought killed thousands of head of cattle on the Jornada. According to the Palmer Drought Severity Index, there was a significant period of drought between 1899 and 1907.

The Honorable Merritt Mechem, judge of the Seventh Judicial District Court of New Mexico, commanded that Hiram Yoast (the third man from the left) appear at the Hillsboro Courthouse on February 19, 1914, at 9:00 a.m. Yoast was accused of "drawing, flourishing and discharging of said pistol" in the town of Cutter. The district attorney was H.A. Wolford, and Hiram's attorney was E.D. Tittmann of Hillsboro.

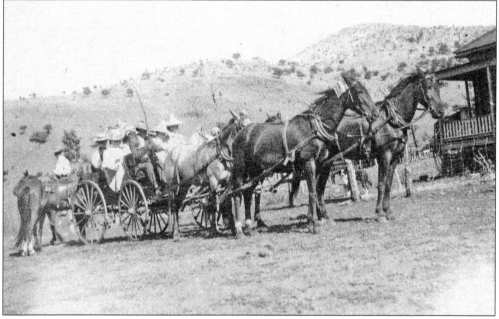

This photograph is of the Pitchfork Ranch. In 1910, James Hiller of the Pitchfork Ranch near Hillsboro credited his life to his silver watch. A horse kicked him, and the watch broke the force of the kick. He escaped serious injury but did end up with a broken rib. The watch was badly crushed and needed to be replaced.

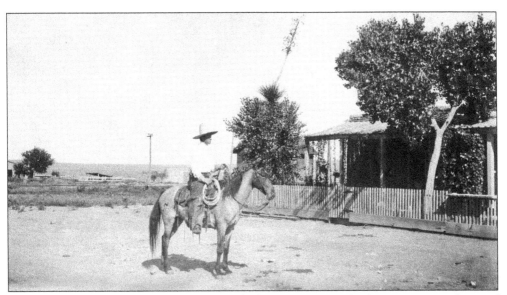

History says that the town of Engle was named after engineer R.L. Engle, supervisor in charge of the construction of the Santa Fe's El Paso–Albuquerque rail line in the 1870s. The railroad tried to change the spelling of the name to Engel around 1920 in honor of its president, Edward Engel, but the town was quick to rally Congress, the post office, and all its citizens to keep it Engle.

The station at Engle was built right in the center of the Jornada del Muerto and became one of the area's largest railroad towns, allowing a point of departure for freight and passengers traveling to Palomas, Cuchillo Negro, Cañada Alamosa, and other areas. Virginia (left) and Jeanette White are at the Engle Depot in the early 1930s.

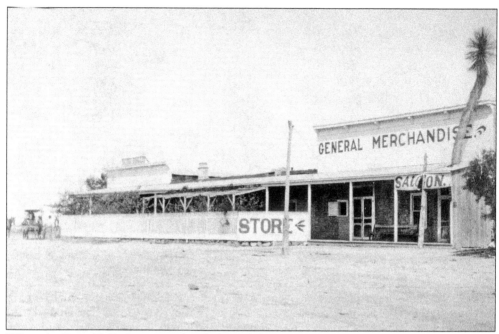

When the Santa Fe Railway completed a branch line from Deming to Nutt for the Black Range camps, Engle suffered. Then Engle became the focal point for cattle drives. It was estimated that drives from a 100-mile radius poured 20,000 cattle a year into Engle to be shipped out to other areas. The Hickcock Hotel, seen here, was said to be a favorite meeting place for cowboys.

The sign on the far right indicates that this adobe building is the Engle Hotel. In the early days, there was a ranch half a mile west of Engle that was owned by wealthy Henry G. Toussant. He was known for his cattle and the speed of his horses. He claimed that one of his horses could go to Palomas, 27 miles away from Engle, in two and a half hours.

Doug Cain came to Sierra County in 1929. He owned the Buckhorn Ranch east of Engle. Cain was a longtime member of the New Mexico Cattle Grower's Association and the Engle Community Church. He also served his community on the board of county commissioners. Cain's obituary from 1972 lists him as a prominent pioneer rancher of Sierra County.

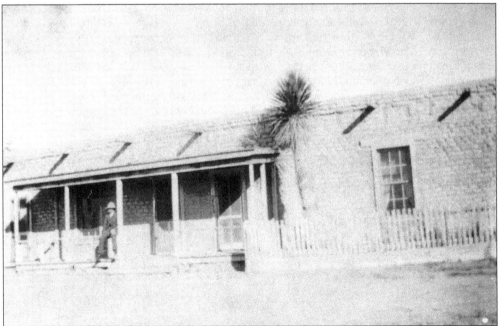

It was said in 1887 that the there was so much water on the plains near the San Andres Mountains that cattle from the Detroit and Rio Grande Ranch were drifting into the neighborhood. This photograph shows the Detroit and Rio Grande Ranch's headquarters, located in Engle.

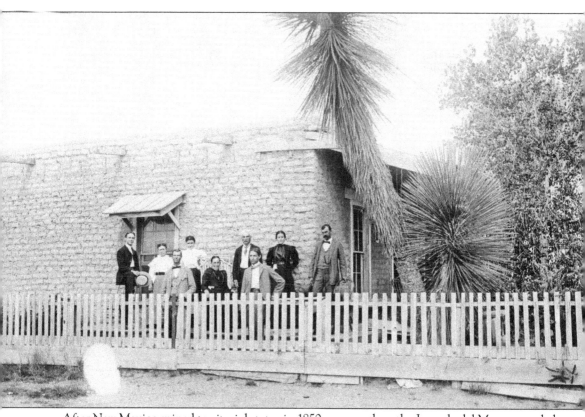

After New Mexico gained territorial status in 1850, areas such as the Jornada del Muerto needed a more permanent source of water to bring safe and timely travel through to more populated areas such as El Paso, Texas. Isolation was no longer an option for the rural areas. History credits Lt. John "Jack" Martin, born in New York, with digging a 164-foot-deep well at the area known as El Aleman on the Jornada del Muerto. He stuck water and proved that survival on the desert was possible. This opened up the way for permanent ranching in the area. In 1890, it was said that from Fairview to Engle was one vast cattle range, with the largest cattle companies in the territory having their headquarters in Engle. This photograph shows the headquarters of the historical Detroit and Rio Grande Ranch. The woman in the dark dress in the middle of the picture is said to be Mrs. William Holmes.

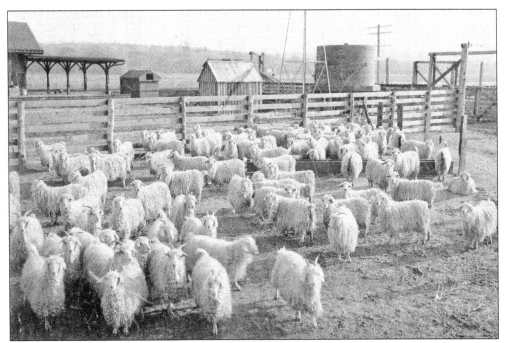

In 1905, the US Forest Service was established as an agency of the US Department of Agriculture to manage public lands in national forests and grasslands. Until this time, New Mexico was a leader in the goat industry. However, within the next few years, 90 percent of the goats were eliminated from the national forest ranges.

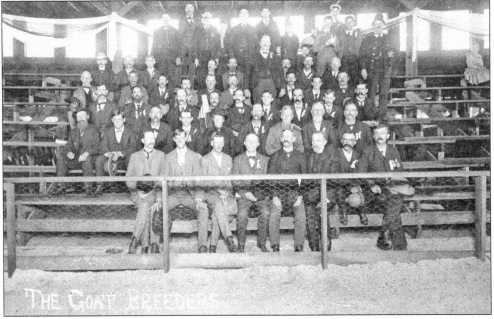

In 1906, Margaret Reid won grand champion at the Chicago Fair. At its peak, her herd grazed on more than 40,000 acres of land. In 1910, she was the only woman allowed in the Goat Breeder's Association. This picture shows the male-dominated Goat Breeder's Association, with Margaret Armer seated fifth from left in the second row.

Angora Journal

DEVOTED TO THE MOHAIR INDUSTRY

INTERNATIONAL PUBLICATION IN TWENTY-THIRD YEAR

VOL. XXIII. PORTLAND, OREGON, JANUARY, 1934. No. 1.

Historic Part Played in Mohair Industry by Excellent Woman Who Answers Call to the Last Roundup.

MARGARET McEVOY REID-ARMER
(1864 - 1933)

M RS. MARGARET ARMER was not with her family and friends at Kingston, New Mexico, this latest yuletide; but her spirit of cheerfulness, fortitude and confident enthusiasm is a living memory to mohair producers in many states. To the editor of the Angora Journal, her passing at Los Angeles, Dec. 22, is a personal bereavement.

Her letters were always optimistic, and it would be well for all of us to emulate her staunch faith in the future, her determination to conquer all obstacles. An undaunted courage reflected the kindly soul of this estimable woman, who was among the earliest to adopt the mohair industry as her profession.

That she made a name for herself throughout the world, and was known as "The Angora Queen," is merely a reflection of her thoroughness and energy—a resolute and firm belief in the merits and eventual recognition of mohair as the world's finest, most ancient and enduring textile material.

The summons came suddenly, just after her arrival at the home of her sister, Mrs. Mamie Rannels, 1127 Wilshire boulevard, Los Angeles. She met it as she met every problem of her eventful life—with womanly courage and a high spirit.

Fearless in expression, as in action, Mrs. Armer had supported her belief in the little mohair goats by exhibiting at livestock shows in many parts of the country. Her fame as a breeder of registered stock was maintained for over forty years, and has been augmented by her sons. She sold breeding sires and dams to all states where mohair is grown; she was a judge of quality in animals and fleece. Widely read and studious, she became an authority on breeding and flock management, respected and highly valued as a loyal friend to thousands in the industry. Her passing is a definite loss to the mohair business in America.

Beginning in this issue, the Angora Journal will publish (serially) extracts from a history of mohair production in America, which includes experiences and observations recorded by Mrs. Armer in the later years of her life. (Please turn to Page Six)

In 1880, sixteen-year-old Margaret was in Kingston with husband Simpson Percy Reid, who was involved in the mines. The Reid family bought a tract of land they called Saw Pit and set about raising children, chicken, and goats while Reid worked in the mines. In 1892, Simpson Reid died of typhoid, leaving Margaret to raise six small children. She started raising Angora goats when she discovered the value of angora as a fleece product for the making of mohair. When drought hit and the cattle failed, Margaret slaughtered her goats for meat to sell to the miners. In 1887, she obtained an Angora buck bred by Dr. C.P. Bailey of California, one of only two breeders of Angora goats at the time. In 1894, she married Leven Edward Armer, a mining engineer. Their union added three more children to the family. Margaret's herd of Angora goats grew, and so did her reputation as the "Angora Queen of America." With her breeding stock in demand, she won top honors competing with men at the St. Louis World's Fair in 1904.

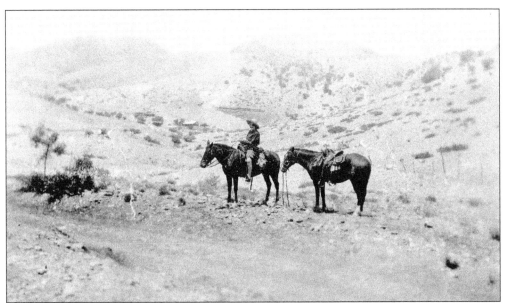

The availability of moisture for the land, influenced by rain and snowfall, played a large part in the settlement and the economy of Sierra County. Unfortunately, rain and snowfall could not always be predicted or counted upon in the middle Rio Grande basin. This photograph identifies the land only as being the Charley McKenney Ranch near Lake Valley. (Courtesy of Merry Jo Fahl.)

Archibald Latham, shown at right with his wife, Nellie, left Texas with his parents at the age of 11 and settled in on the Brenda (Berenda) Creek near the town of Lake Valley. In 1896, he married Nellie and raised his family on the ranch. Latham carved out his living as a rancher (or stockman) in the sheep and cattle industry. He died at the age of 70 in Lake Valley.

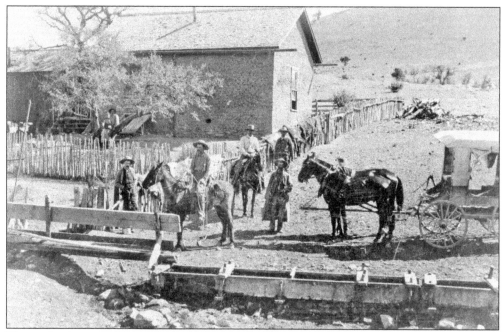

This early photograph is of the Calhoun ranch. The H.O.K. Ranch, located in Cuchillo, was founded by Frank Augustus Calhoun and operated by him until 1931, when it was sold to the H.O.K. Ranch Company. His son, John Clinton Calhoun, had operated the ranch under his father's ownership and continued to work at the ranch under the H.O.K. Ranch Company as assistant manager.

In 1920, J.A. Wigmore of the Hermosa Land & Cattle Company shipped eight polo ponies from the Jawzoo Ranch just north of Hillsboro. The ponies were to be used in a polo tournament in California. Sam Lard owned the Jawzoo Ranch, which was later incorporated into the Ladder. The grandfather of Mike and Freddie Torres, of Truth or Consequences, worked on the Jawzoo. (Courtesy of Hillsboro Historical Society.)

William Samuel Hopewell and his partner, a Mr. Brooks, bought up local ranches in Sierra County. In 1884, Hopewell organized the Animas Land and Cattle Company at a cost of one million dollars. The ranch would later become the Ladder Ranch. The photograph above is of Ira Faulkner, who worked at one time on the Ladder Ranch. The image below shows a group of students from Arrey Elementary with their teacher, a Mrs. Dawson. Some of the students pictured here came from ranching and farming families in the area. Many were the children of workers who had located to the area looking for jobs, for land, and for a new start in life.

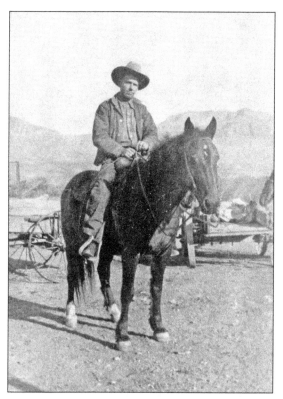

Bill Hopkins remembers that around 1938, his father, Henry Hopkins (at left on the horse) moved from the family's Caballo-area ranch to higher ground. His land was part of the area that was to be flooded in the creation of the Caballo Dam and Reservoir. Hopkins and his wife, Velma (née Cox), continued to live and ranch in the Caballo area. Velma, shown sitting on a porch below, worked as postmistress for the Caballo Post Office. The Cox family also lost land in the development of the irrigation dam. The Cox family moved to the Palomas Creek. (Both, courtesy of Bill and Shairlee Hopkins and Hank and KeliKay Hopkins.)

Seven

HOT SPRINGS, SALOONS, AND GAMBLING

Early settlers came not only to drink the naturally occurring spring water in Palomas Hot Springs (later shortened to Hot Springs) but also to bathe and soak in the water and mud. The hot thermal water ranged in temperature from 98 to 115 degrees, and it provided a natural relief for those suffering from physical ailments such as rheumatism.

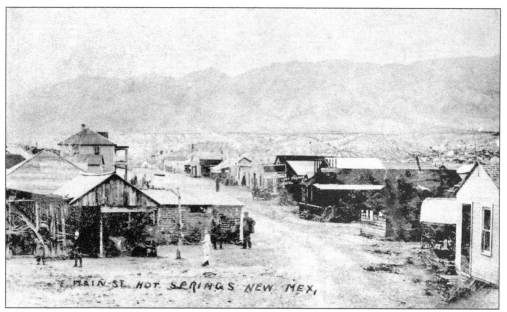

E. MAIN ST. HOT. SPRINGS NEW MEX.

A road was built to enter Sierra County from the north and travel between the river and the mountains directly to Las Palomas. However, the residents of Palomas Hot Springs requested and were given a road that ran through their town and then south to Las Palomas. The road was built with convict labor.

Eugene and Amelia Goetz were the children of Otto Goetz, who was born in Germany. Otto had come to Palomas Hot Springs and opened up one of the first stores. Goetz organized some of the prominent citizens of Palomas Springs into a community group called the Commercial Club, a forerunner to the chamber of commerce, to advertise the healing mineral waters.

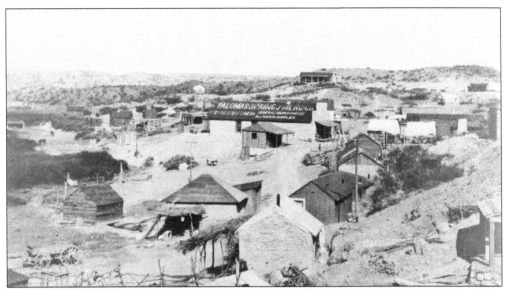

In 1915, at the age of 35, Madame Daisy De Swayzee was found kneeling on the dirt floor of an abandoned shack, her face to the wall, dead from a gunshot wound. Her companion, J.H. Hamilton, 55 years old, had also been shot and buried in a shallow grave in the dirt floor of that same shack. The brutal crime was almost unfathomable to the small community of Las Palomas.

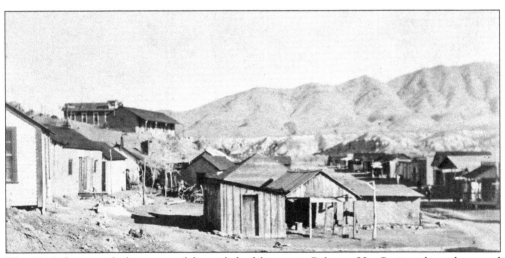

This 1916 photograph shows one of the early bathhouses in Palomas Hot Springs, later shortened to just Hot Springs. The bathhouse, pictured front and center, stood on Main Street. As early as 1914, Palomas Hot Springs appeared to be on its way to offering the baths commercially. The baths were free in 1914 because of the revenue brought in to other local businesses by those visiting the baths.

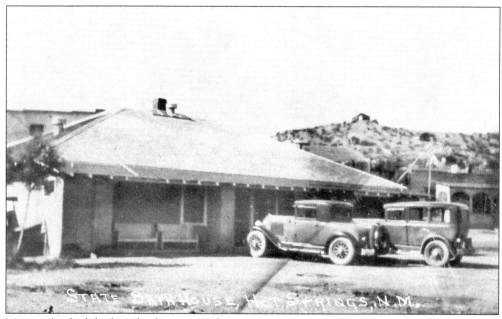

Many individuals had tried to homestead the area around Palomas Hot Springs, but Fount Sullivan obtained the first legal claim to the land (122 acres) in 1897. He built the first bathhouse in 1910 and was said not to charge anyone for the baths. In about the same area, the State Bath House was built in 1919 using state funds.

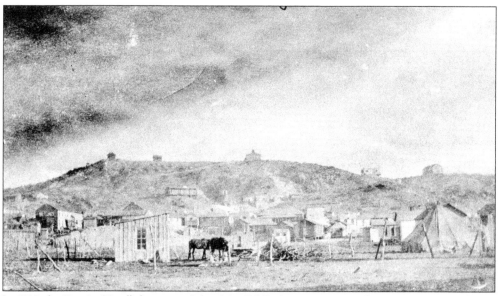

In 1919, the *Deming Headlight* reported that Mrs. Ed Dickinson was spending some time at Palomas Hot Springs because of her condition of rheumatism. Edith Stone and Grace Reynolds were also headed to Palomas Hot Springs, but they intended to do a little fishing. As avid fisherwomen, they had a "stock of villainous tackle that would hold a whale." The photograph shows the town in 1919.

This photograph shows the James Mineral Baths. The natural spring water came straight from the underground springs. Drinking the water was said to relieve and sometimes cure chronic inflammation of joints, muscular rheumatism, chronic bronchitis, asthma, pleurisy, stomach trouble, neuralgia, neuritis, insomnia, varicose veins, and fatigue.

To the left in the photograph is the James Apartments, and to the right is the bathhouse. The James Apartments building had originally been at the damsite of Elephant Butte as either a mess hall or a dormitory. The building was auctioned off after the dam's completion, dismantled, and hauled by wagons in pieces down to the town of Palomas Hot Springs, where it was reconstructed.

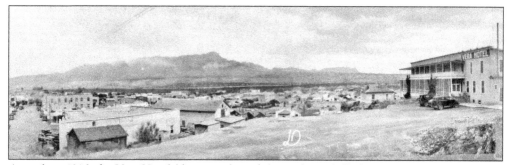

As early as 1916, the Vera Hotel (shown at far right) stood on a hill above Hot Springs, open and ready for business, renting rooms for $1 a night. In 1929, it advertised hot and cold water, steam heat, reasonable rates, convenience for bathers, electric lights, amusements, and traveling men's headquarters (whatever that meant).

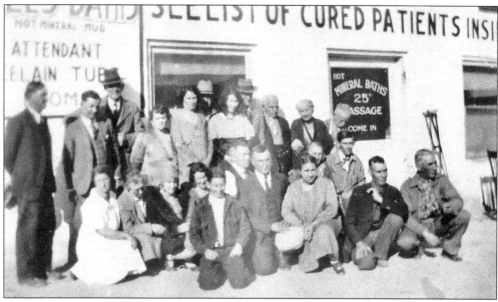

In 1929, Hot Springs had 10,000 visitors, according to an old brochure that calls the town a "spa town." Early facilities had charlatans pretending to be doctors. The facility pictured here was run by a hotel owner calling himself "Dr. Mills." As time progressed, sanitary municipal and private bathhouses provided facilities at reasonable rates and were under the direction of physicians, chiropractors, and masseurs.

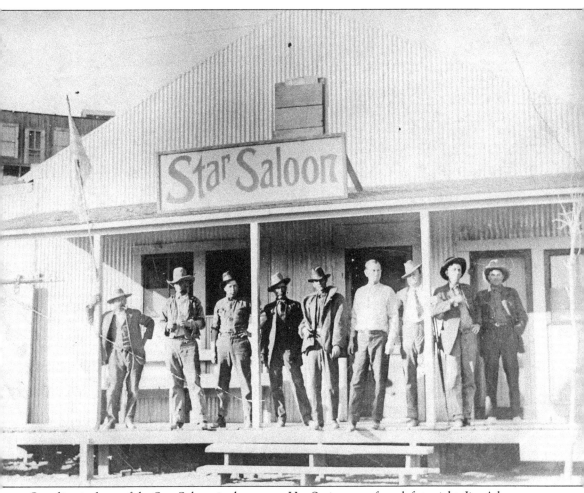

Standing in front of the Star Saloon in downtown Hot Springs are, from left to right, Jim Adams, Buck Miller, Joe Tafoya (owner), Sena Tafoya, Sam Hidalgo, Claude Heffernan, Harry Bensen, Jack Helms, and Jack Page. In the early 1920s, it was said that a genuine "flapperett" (a term used in the 1920s to insinuate a woman of supposedly less than impeccable morals) dazzled the eyes of modest Hot Springs. It was also reported that early one Saturday morning, Walter Waite (also known as "Slim the Cook") invaded a poker game and stuck up the players with a .45 pistol. He took $240 from the players and, afraid that they might think he was joking, shot a hole in the wall before he departed. Waite was quickly rounded up by law enforcement and sent to Hillsboro, where he waived examination and was bound over to the grand jury for the sum of $2,000.

The picture show in Hot Springs could not have been any more exciting than the January 4, 1929, *Albuquerque Journal* headline "Bobbed Bandits Rob Hot Springs." The "bobbed" women relieved the Liberty Pool Hall and the Hot Springs Pharmacy of $700 and some merchandise. The women, who were seen leaving Hot Springs just after 2:00 in the morning, got into two separate automobiles driven by men, both with Texas license plates. The same bob-haired bandits were also implicated in a third robbery in Hot Springs. Police thought they had found one of the male suspects and sent for Hot Springs mayor Leo Smith to make the identification. Mayor Smith could not identify E.D. Clardy as one of the suspects or drivers in the robbery. Clardy had been arrested in El Paso with an alleged bank robber named Ace Pendleton. Apparently, all eyes had been upon the young women, as everyone remembered their hair and descriptions, but nobody could remember what the men had looked like.

In 1941, the Republican district attorney ordered all gambling outlawed in Sierra County and all gambling devices banned. District attorney Claron Waggoner said that "a lot of unfavorable notoriety" for Hot Springs and a "great number of requests from Sierra County citizens" had resulted in the order to "Clean-up Sierra County." In 1944, Ray Stanley had the license for the bar at the Arizona Hotel (above) and controlled the gambling room.

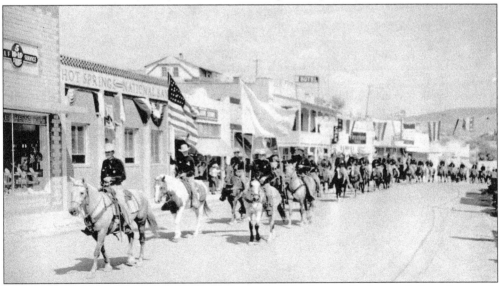

In 1950, New Mexico State Police in plain clothes raided Hot Springs. Six bars raided simultaneously had $8,000 worth of gambling equipment confiscated. The slot machines, dice tables, and roulette wheels were taken to the town dump, soaked in gasoline, and burned. The parade celebrating the town's name change from Hot Springs to Truth or Consequences was held around the same time.

On May 12, 1932, the *Sierra County Advocate* reported that two days earlier the Hot Springs National Bank had been held up and robbed at noon. The robber had come into the bank, where cashier Grade Jones and teller Henry Lard were going about their usual routines. The robber, however, "violated the Private, Keep Out precepts of the institution," stuck a gun in their faces, and ordered them to "stick 'em up." Forcing them into the vault, he cleaned out the cash drawer and made a hasty exit. Evidently, others in the vicinity of the robbery were clueless. Some individuals said that there were at least two robbers, possibly three, maybe short, maybe tall, but they did have a car parked near the Woolf Apartments. Everyone agreed that they made a hasty retreat in a Chevrolet coupe. Although numerous posses were formed and all roads searched coming into town, no trace was found. The only thing that everyone agreed upon is that the robbers stole $3,414.

Eight

"HELLO THERE! WE'VE BEEN WAITING FOR YOU"

Sierra County had 14 school districts operating throughout the county in 1884: Lake Valley, Hillsborough (Hillsboro), Kingston, Las Palomas, Cuchillo Negro, Zapata, Grafton, Cañada Alamosa, San Jose, San Albino, Hermosa, Fairview, Chloride, and Engle. A caption on the back identifies these youngsters as "the Hillsboro Boys." Some districts held school for seven months so students could help out during planting times on the farms.

In this 1929 photograph, the man on the far right is identified as Tom Hobbs, an early developer in Hot Springs. One of the other two men is Charlie Henson. Henson, along with Hobbs, gave 62 acres to increase the property needed for building Carrie Tingley Crippled Children's Hospital. In 1932, Henson's daughter Wyona and his son Charles went to Grafton. As they were coming home, the truck's gears became disengaged, causing it career off a steep grade, cross an arroyo, and nose-dive into a dirt bank. Charles got out, but Wyona was stuck. A fire started, and Charles managed to free Wyona, tearing off her burning clothes. Charles covered Wyona with some of his clothing and went for help. Headed toward Fairview, he met C.V. Jackson. They returned to the wreck, hastily loaded Wyona into Jackson's vehicle, and drove her to Dr. Sutton's Sanatorium in Hot Springs. Wyona died at the age of 15, and Charles was uninjured other than the burns received while rescuing his sister. Today, street signs still bear the names Wyona, Charles, and Henson; Hobbs Street was renamed Broadway.

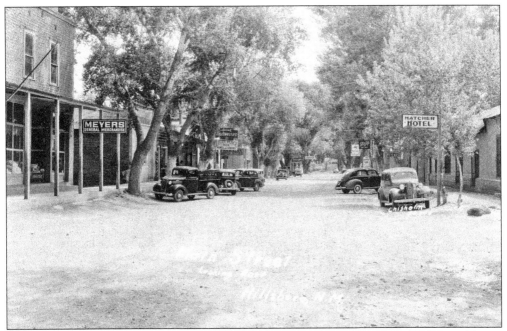

In 1922, Jeff Hirsh was literally entombed in a 180-foot mine shift in the town of Hillsboro (shown here in the early 1920s). Oscar Hirsch, his son, was working on top of the shaft when the cave-in occurred. He was able to climb out and run four miles to the nearest telephone to call for help. Little hope was held out for Jeff's survival.

In 1923, Rep. Frank Winston (for whom the town of Fairview, shown here, was renamed) introduced a bill that would open fishing at Elephant Butte Lake between April 15 and October 15. Nonresidents would be able to obtain fishing licenses for $1.25 a month instead of the $5 nonresident license. He had received complaints from nonresidents who objected to paying the $5 fee for a few days of fishing.

In 1924, Henry Kendell and Charley Martin man the fire department's chemical engine, Jimmy Knox and John Orekar are on the hose nozzle, and Phillips and Pat Solise are on the hand fire extinguisher and lanterns. Ralph Daniels and son Grogan were the laddermen, and Hefferman and Wilson were on the bucket brigade and the extra hose lines.

This Catholic church in Hot Springs was one of many churches throughout the history of Sierra County. It is identified as the first Catholic church built in Hot Springs and stood on the corner of Date Street and Fifth Avenue. The photograph was taken in 1929.

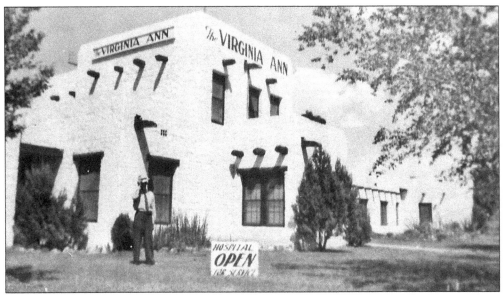

The Craig family operated the Virginia Ann Hospital in 1948 and claimed to help those suffering from arthritis, neuritis, rheumatism, and alcoholism. The hospital was located on the corner of Austin and Clancy Streets in Hot Springs. When the hospital became the St. Ann's Hospital in the late 1940s, it was run by the Catholic Sisters of the Sorrowful Mother, a German order of nuns.

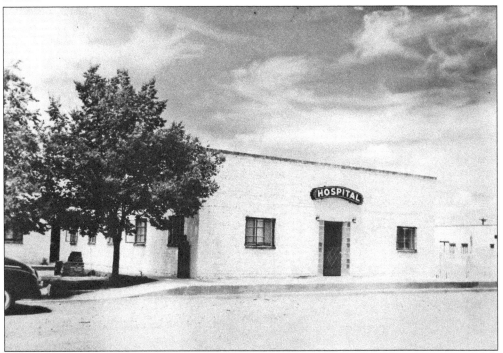

A wing was added to the Virginia Ann Hospital, shown here. At that time, the hospital had nine physicians. The Virginia Ann Hospital was leased from a Mrs. Frost and a Mr. Collins for a 10-year period. The first sisters at Hot Springs were Sister M. Rosalinda, Sister M. Viola, Sister M. Guadentia, and Sister M. Encratia.

The same year this photograph was taken, 1941, the United States entered into World War II. In Sierra County, young men still wore cowboy hats, played the guitar, and hung out with their friends. From left to right are L. Don Pack, R.C. Woolf, Wilton Woolf, Claude Martin, and Dale Woolf. (Courtesy of Russell Woolf and La Vern and Jimmy Walker.)

In the late 1940s, the El Rancho Café, located on North Broadway, served steaks and Mexican food. Its black-and-white checkered tile floor and its pristine white tablecloths made it an attractive place for locals and tourists alike. All the waitresses wore white shirts with a tied bow around their collars. Coffee drinkers often cozied up along the bar to chat.

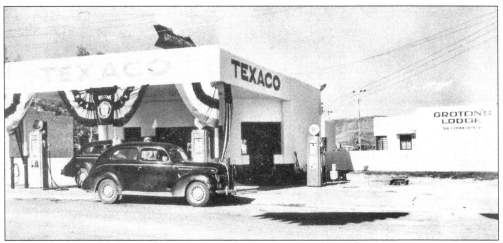

This Texaco gas station and the Groton's Lodge were out on South Broadway toward the adjoining town of Williamsburg. In the 1940s, there were 19 bathhouses and masseurs and 51 hotels, cottages, and rooming houses in Hot Springs. Sierra County had a population of 6,962, and Hot Springs' population had risen to 2,940.

Elizabeth (behind the bar) and husband Sheriff Bill Sullivan (next to her at right) are at Cuchillo Bar in Cuchillo. The Cuchillo Bar was a favorite watering hole for many. Oral history says that the bar was originally a stagecoach stop where freight was hauled to and unloaded. That freight would then be reloaded onto wagons and hauled to the mines in the Black Range. (Courtesy of Josh Bond.)

A.C. Woolf stands on Broadway Street. In the background are, from left to right, the Food Mart, George's Bar, and Ken Umberson Jeweler. To the right is the Broadway News Store, which also sold fishing tackle. George's Bar was a popular watering hole in the 1940s. Across the street, George's wife, Bessie, had her own bar, which was called Bessie's. (Courtesy of Russell Woolf and La Vern and Jimmy Walker.)

In 1945, partners Henry Kaiser and Joseph Frazer started a joint adventure to build automobiles. Their first car was a 1947 Kaiser Special, a four-door sedan with a six-cylinder engine. Kaiser and Frazer cars had bodies made with welded steel. In 1947, A.C. Woolf owned the Kaiser Frazer Dealership at 2255 South Broadway in Hot Springs. (Courtesy of Russell Woolf and La Vern and Jimmy Walker.)

Clyde Cole settled in Hot Springs with his wife, Ola Mae, in the late 1930s. He ran a Conoco station, a storage facility, and a cattle-hauling business. The first thing Clyde did upon arriving was to join the volunteer fire department, where he served as chief for many years. Back then, one of the department's fundraising projects was blowing the fire whistle, then stopping all the cars that followed the fire trucks. The offender either got a ticket for unlawfully following fire trucks or gave a donation. Clyde served on the city council as mayor pro tem (acting as mayor when the actual mayor was ill). Meetings could be quite the exciting affair. Tempers flared quite often. Dr. T.B. Williams was on the town council with Clyde. They disagreed, and it came to blows. No one remembers what it was about, who won, or if anything was settled. Clyde died in February 1956 while hauling sheriff posse horses from El Paso, Texas, in a snowstorm. (Courtesy of Ann Welborn.)

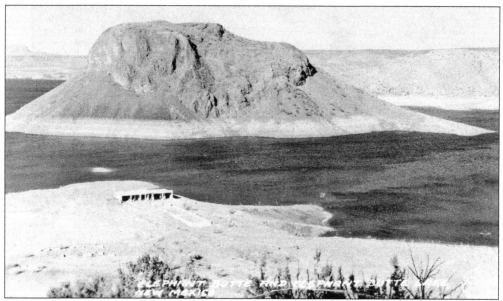

Gov. Clyde Tingley loved Elephant Butte Lake (pictured) and taking his big boat, *Carrie Tingley*, out on the water. He took children from the Carrie Tingley Crippled Children's Hospital out for rides and fishing trips on the boat. In 1937, Glenn Mims, assisted by Jay Sharp, built the docks at the damsite, according to Nita Mims. Mims held the concessionaire at Elephant Butte Lake in 1937.

From left to right are (first row) little Louise Witt and Lewis Pennington; (second row) Jake Witt, Laura Witt, Louise Witt, and Katie Dowell. Sierra County offered hunting in the Black Range and surrounding mountains for quail, pheasants, deer, wild turkey, bear, wildcats, and other animals. The county was well on its way to being a popular tourist area.

Harley Brock was in the US Marine Corps in Tennessee when he received a call on March 27, 1943. Harley's brother Robert and three other Boy Scouts had drowned at Elephant Butte Lake. Harley, his grandfather, and Frank Ellis used a rope and a large grappling hook with smaller chains on the end to drag the lake. Frank, missing his arm, used his foot to pull the rope up. On day six, Frank asked for help. Harley said, "The next thing I saw as I kept pulling the rope was the bottoms of a pair of work boots, and at the surface of the water, my brother Robert. His body floated free, not one hook in his body or clothes. A piece of chain had been hooked on his boot. It came free, and we got his body into the boat, with his elbows bent and his hands gripping in front of his face as if holding on to the boat." The body was so well preserved it appeared to be six hours old rather than six days.

After the tragic death of the Boy Scouts on Elephant Butte Lake in 1943, deputy game warden Jim Hall said that boats that did not meet all safety requirements would not be licensed for use on the lake. Metal boats would no longer be licensed unless the boats were equipped with air chambers. The tragedy of 1943 allowed individuals like Lester John Carpenter, shown at left, to safely enjoy Elephant Butte Lake.

Maxine Fletcher (shown at right with daughter Sherry) rescued two men on Elephant Butte Lake. An inquest was held into the drowning death of the third man, Cicero Sitton. He had not sunk but had been held afloat by his waterproof jacket. The other two men had clung to the boat in the cold water till Maxine spotted and rescued them.

Standing in front of the Pine Knott are, from left to right, Wilton Woolf, A.C. Woolf (owner), and Dale Woolf. In an August issue of the *Water Hole* in the 1960s, it was said that it "seems to be a neck and neck race between the Pine Knott and Ashbaugh's for the dancing crowd." The Pine Knott added a piano and "chi chi bar." (Courtesy of Russell Woolf and La Vern and Jimmy Walker.)

Sitting in front of the White Place, the main house on the Woolf Ranch, in 1937 are, from left from right, sisters Lena Woolf Walker and Lona Woolf Pack. Their father, A.C. Woolf, bought the ranch in 1931 and gave the house its name. (Courtesy of Russell Woolf and La Vern and Jimmy Walker.)

123

Standing from left to right are Freddy Torres, Terry Miller, Frank Sullivan, R.C. Woolf, an unidentified liquor distributor, D.W. Falls, and Kenneth Mims. They are celebrating the building of the Sheriff's Posse Rodeo Arena. The Sierra County Sheriff's Posse, organized by Roy Stovall in 1939, consisted of town and county businessmen. On a few acres they leased from the city, they financed the building of their own stables and corrals. Later on, the city asked the posse to take over that site, and they willingly agreed. The posse financed rodeos and the building of the rodeo corrals, stables, and bleachers. When Hot Springs officially became Truth or Consequences and Ralph Edwards arrived in town, the Sierra County Sheriff's Posse initiated Edwards by undressing him on the streets of Truth or Consequences and having him put on the regulation uniform. Edwards then mounted a palomino stallion and led the parade. His wife, Barbara, rode with the Sheriff Posse's Auxiliary. (Courtesy of Grace and R.C. Woolf.)

From left to right are two unidentified US Army representatives, Ernest Potter, R.C. Woolf, Charley Hardin, and A.C. Woolf. These Sierra County men gathered for a meeting with personnel from the White Sands Proving Grounds (now White Sands Missile Range). The Army had systematically been acquiring ranches since 1942 in order to support the vision of White Sands Proving Grounds. In March 1949, the Army acquired the Sierra County ranches on an exclusive use basis through eminent domain, paying the ranchers only a fraction of the value of their ranches. All of the men seen here, with the exception of the men in uniform, owned ranches or had long-term leases on land that the Army wanted for White Sands Proving Grounds. A historic preservation plan was to be developed and put in effect for each of these properties as the Army deemed appropriate. (Courtesy of Russell Woolf and La Vern and Jimmy Walker.)

From left to right are (first row) Daniel Terrazas and Anna Terrazas Nunez; (second row) Johnny Terrazas, Delia Terrazas McCarthy, Eloy "Sonny" Terrazas (looking up and smiling), Ronald Armijo (in front of Sonny in a white shirt), and Gilbert Terrazas (in striped shirt); (third row) Cecilio Terrazas, Andrea Terrazas Salas (in the coat), Elivoria Ortega Terrazas (behind Andrea), Julia Carrejo Armijo, Teresa Terrazas Duran, Kathleen Armijo Terrazas, and Ricardo T. Armijo. The photograph was taken at the home of Horacio and Kathleen Terrazas in the canyon of Las Palomas. The original townsite of Las Palomas (Spanish for "the doves") was established in the 1850s. It was moved in 1938 a mile west of its original site when the Caballo Dam was built. The US Bureau of Reclamation bought out most of the original townsite. (Courtesy of Daniel Terrazas, Kathleen Terrazas, and Charity Lang.)

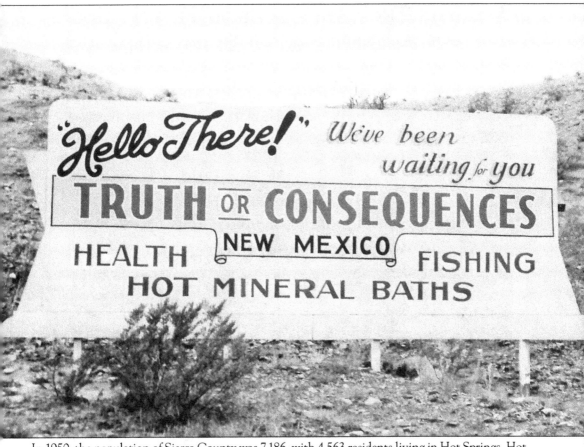

In 1950, the population of Sierra County was 7,186, with 4,563 residents living in Hot Springs. Hot Springs mayor Jewell Glenn Mims, known as Pop Mims, wrote the letter that was read on the air by radio host Ralph Edwards saying that the city council of Hot Springs had unanimously voted at the regular recess meeting on March 21, 1950, to change the name of Hot Springs to Truth or Consequences, New Mexico, and all legal formalities would be taken to ensure the name change. Two elections later, it became a reality. The sign with the welcoming words "Hello There! We've been waiting for you" would greet the 1950s.

DISCOVER THOUSANDS OF LOCAL HISTORY BOOKS
FEATURING MILLIONS OF VINTAGE IMAGES

Arcadia Publishing, the leading local history publisher in the United States, is committed to making history accessible and meaningful through publishing books that celebrate and preserve the heritage of America's people and places.

Find more books like this at
www.arcadiapublishing.com

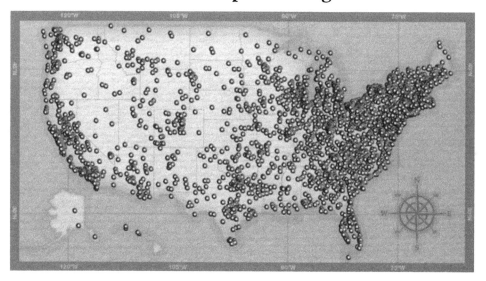

Search for your hometown history, your old stomping grounds, and even your favorite sports team.

Consistent with our mission to preserve history on a local level, this book was printed in South Carolina on American-made paper and manufactured entirely in the United States. Products carrying the accredited Forest Stewardship Council (FSC) label are printed on 100 percent FSC-certified paper.

MADE IN THE

Printed in the USA
CPSIA information can be obtained
at www.ICGtesting.com
LVHW071108281223
767380LV00080B/153